# Tiffany's Swedenborgian Angels

STAINED GLASS WINDOWS
REPRESENTING THE SEVEN
CHURCHES FROM THE
BOOK OF REVELATION

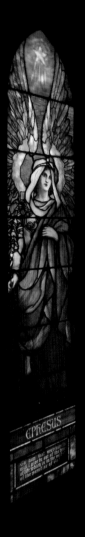
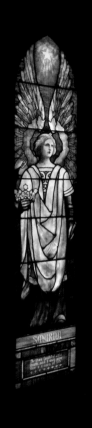
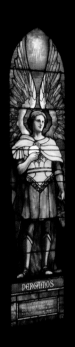
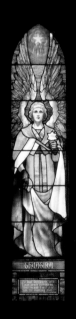

# Tiffany's Swedenborgian Angels

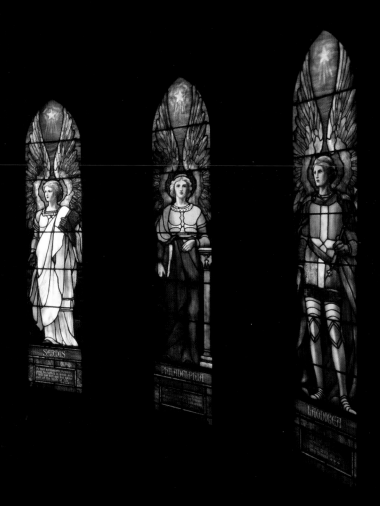

# Stained Glass Windows Representing the Seven Churches from the Book of Revelation

Mary Lou Bertucci *and* Joanna Hill
*With contributions from*
Art Femenella, Susannah Currie
*and* Carla Friedrich

Swedenborg
Foundation
Press

*Dedicated to Ms. Helene M. Tripier*
*whose generosity began the journey of the angels into the light.*

*Library of Congress Cataloging-in-Publication Data*
Bertucci, Mary Lou.
  Tiffany's Swedenborgian angels : seven stained glass
windows representing the seven churches from the Book of
Revelation / Mary Lou Bertucci and Joanna V. Hill.
      p. cm.
  Includes bibliographical references and index.
    ISBN 978-0-87785-339-8 (alk. paper)
1. Tiffany, Louis Comfort, 1848–1933. 2. Stained glass
windows—Ohio.
3. Angels in art. 4. Bible. N.T. Revelation—Illustrations.
5. New Jerusalem Church—Ohio. I. Hill, Joanna V. II. Title:
Swedenborgian angels. III. Title: Seven stained glass windows
representing the seven churches from the Book of Revelation.
NK5398.T52B47 2011
    748.50973—dc22
        2011013117

Angel window photography by Douglas A. Lockard
Historic and restoration photographs courtesy of *In Company
with Angels, Inc.*

Excerpts from *Revelation Unveiled* by Emanuel Swedenborg
were translated by George F. Dole.

Edited by Morgan Beard
Design by Joanna V. Hill
Typesetting by Karen Connor
Art Research by Alexia Cole

Printed in China
through Asia Pacific Offset

Swedenborg Foundation Press
320 North Church Street
West Chester, PA 19380
**www.swedenborg.com**

# Contents

# Foreword

by the Reverend Susannah Currie

*Former pastor of the Swedenborgian Church at Temenos
and executive director of* In Company with Angels

From the moment the seven grimy packing
crates were opened in 2001 to reveal the stained
glass windows Tiffany Studios named *Angels
Representing Seven Churches,* these windows
have inspired the people who see them to look
beyond surfaces and to find ways to bring
beauty out of darkness and into the light.

The first people to be inspired were a
small group of members of the Swedenborgian
Church at Temenos, the retreat center near
West Chester, Pennsylvania, that owns the
windows. Their church, based on the writings
of eighteenth-century scientist and mystic
Emanuel Swedenborg, teaches that the purpose
of human life is to prepare to live as angels in
heaven, that angels are present and contribute to
daily life on earth, and that "inwardly, a person
is in company with angels, though unaware."
Another important part of their Swedenborgian
faith includes the spiritual practice of living
"usefulness," which could be thought of, in part,
as doing good works for others. They agreed
that sharing these windows would be a wonder-
ful way to be useful to others.

The nonprofit organization *In Company
with Angels, Inc.* was formed to manage and
fund the journey of the angel windows from
their forty years in darkness into the light

of public awareness. Its board continues the church's impetus to "reveal the beauty" through its mission "to share with the greatest number of people Tiffany's window series *Angels Representing Seven Churches,* to provide education about its historical and artistic significance, to archive its evolution and journey and to ensure its safekeeping for future generations to discover and enjoy."

These stained glass windows depicting the angels from the Bible's book of Revelation represent, in artistic genius, the light of the Divine shining through human creativity and bringing beauty into the world. Viewing these windows and contemplating their symbolism influenced the restoration of the windows, the composition of meditative music, the design of the interactive website, and the creation of the traveling museum exhibit. Museum-goers who have viewed the windows have reported feeling something newly revealed within themselves while in the presence of these angels.

It is a particular pleasure for me to introduce you to these angels through this book. Whether you have seen them in person or are enjoying their images in print, the beauty that shines through them speaks to each person uniquely. Gaze quietly and see for yourself what they lighten in your experience. Take time to contemplate the concept of angels and what you believe about the part they play in your life. They have been a part of my life for a decade. They inspire me daily to seek spiritual understanding hidden beneath everyday life, to look beyond surfaces, and to find ways to bring beauty out of darkness and into the light. ✦

# Tiffany's Swedenborgian Angels

STAINED GLASS WINDOWS
REPRESENTING THE SEVEN
CHURCHES FROM THE
BOOK OF REVELATION

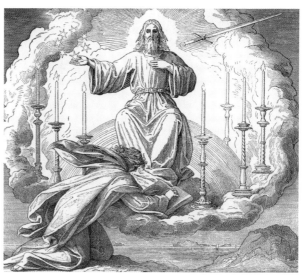

"I am the Alpha and the Omega," says the Lord God, who is and who was and who is to come, the Almighty.

I, John, your brother who share with you in Jesus the persecution and the kingdom and the patient endurance, was on the island called Patmos because of the word of God and the testimony of Jesus. I was in the spirit on the Lord's day, and I heard behind me a loud voice like a trumpet saying, "Write in a book what you see and send it to the seven churches, to Ephesus, to Smyrna, to Philadelphia, and to Laodicea."

Then I turned to see whose voice it was that spoke to me, and on turning I saw seven golden lampstands, and in the midst of the lampstands I saw one like the Son of Man, clothed with a long robe and with a golden sash across his chest. His head and his hair were white as white wool, white as snow; his eyes were like a flame of fire, his feet were like burnished bronze, refined as in a furnace, and his voice was like the sound of many waters. In his right hand he held seven stars, and from his mouth came a sharp, two-edged sword, and his face was like the sun shining with full force.

When I saw him, I fell at his feet as though dead. But he placed his right hand on me, saying, "Do not be afraid; I am the first and the last, and the living one. I was dead, and see, I am alive forever and ever; and I have the keys of Death and of Hades. Now write what you have seen, what is, and what is to take place after this. As for the mystery of the seven stars that you saw in my right hand, and the seven golden lampstands: the seven stars are the angels of the seven churches, and the seven lampstands are the seven churches." —REVELATION 1

# Introduction

A wonderful story of what was lost and was found lies behind the exhibition *In Company with Angels: Seven Rediscovered Tiffany Windows.*

In 1902, the Swedenborgian church of Glendale, Ohio, made a gift of seven full-length windows (each standing eight feet tall) to its sister church in Cincinnati. The windows were installed in a semicircular wall in the sanctuary behind the altar. The seven angels represented the angels of the seven churches described in the beginning of the book of Revelation. One would imagine from their provenance that they would be fierce, yet the angels were youthful and beatific in appearance, vaguely Roman in dress. Some appeared more feminine than masculine; others seemed military, although not threatening. For those who stood in their presence, the

The Swedenborgian New Jerusalem Church of Cincinnati at Oak Street and Winslow Avenue c. 1903.

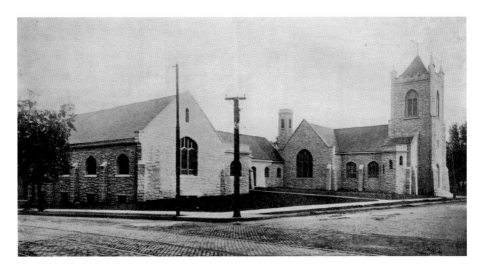

3

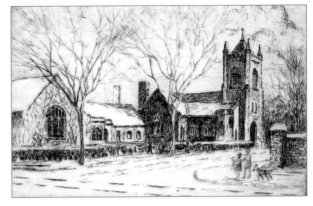

Etching of the New Jerusa-
lem Church of Cincinnati
by F. Dodger, c. 1925.

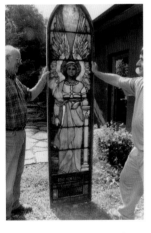

Discovering the windows
at Temenos.

effect was peaceful, solid, and radiant. These
pieces were the masterwork of Louis Comfort
Tiffany, specially designed and created by his
studios in New York. Tiffany's hallmark gem-
like colors glowed in each pane, lending their
brilliance to many Sunday services, weddings,
baptisms, and funerals.

Half a century later, a highway came
through Cincinnati. In 1964, the state of Ohio
tore down the church to make way for Interstate
71. The windows were removed and stored in
various garages and basements, under less-than-
ideal conditions, for many years. In 1986, when
the Swedenborgian Church (the branch known
as the General Convention) purchased a fifty-
three-acre property in West Chester, Pennsyl-
vania, for the Temenos Retreat Center, founder
and director Ernest Martin proposed that the
center purchase the church windows from the
Cincinnati church. In 1989, the denomination
underwrote the purchase price of $50,000, about
half of which was raised through a fund drive.

Architect Eric Lloyd Wright, grandson of
Frank Lloyd Wright, came to the center in 1990
and designed a beautiful conference center
building that would include the seven windows,
and the windows were stored in a barn on the
Temenos property awaiting construction. The
Jacqueline M. Benjamin Studios were con-
sulted, and they verified that these were indeed
Tiffany windows.

When Martin retired from the ministry at Temenos in June 1999, he told incoming minister Reverend Susannah Currie about the windows stored in the barn. When the crates were opened, she was awed by the beauty of the windows. A church committee to determine what to do with the windows became the inspiration for the formation of the nonprofit corporation *In Company with Angels,* whose goal is to share the windows with the world. With a single donation of $50,000 from a generous benefactor, the repair and restoration of the angel windows began.[1]

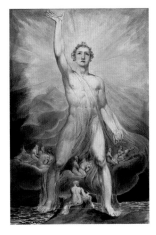

*Angel of the Revelation* (c. 1803–5) by William Blake, watercolor, ink and graphite, The Metropolitan Museum of Art.

The windows were painstakingly restored by the Art of Glass Studio in Media, Pennsylvania, supervised by Femenella & Associates, Inc.,[2] of Branchburg, New Jersey, using Tiffany's original techniques and materials, and have been displayed at museums throughout the United States. (See *Conserving the Windows* at the end of this book for more details on the restoration.)

Throughout the nineteenth and early twentieth centuries, Swedenborgianism was a thriving faith. Based on the writings of the eighteenth-century scientist, theologian, and seer Emanuel Swedenborg (1688–1772), the church had a strong following in the United States and England. Swedenborg's theology was also appreciated by

Swedenborgian pastor and acolytes with angel windows in the background.

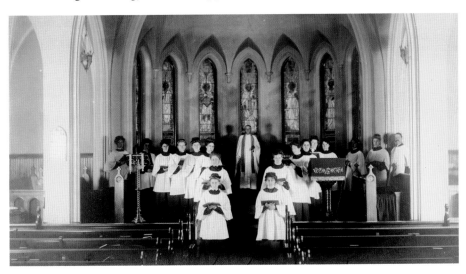

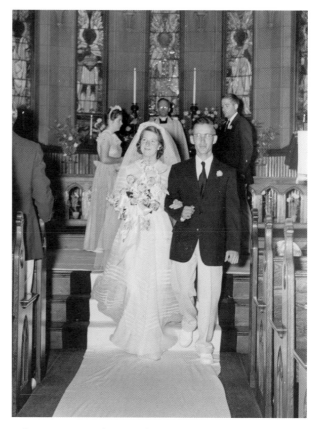

Wedding of Perry Skinner and Temenos Retreat Center founder Reverend Ernest Martin at the Church of the New Jerusalem, Cincinnati, Ohio. The angel windows can be seen behind the altar.

*Engraving of William Blake* (1757–1827) by C.H. Jeens from *Life of William Blake* by Alexander Gilchrist, 1880. An English Romantic poet, painter, and printmaker, Blake was heavily influenced by the writing of Swedenborg. From a young age, he claimed to have visions of God and angelic figures.

others; among his readers were William Blake, Ralph Waldo Emerson, Elizabeth Barrett Browning, and Helen Keller. The father of William and Henry James was an ardent interpreter of Swedenborg. Even Honoré de Balzac wrote a Swedenborgian novella, *Seraphita*.[3]

It is easy to understand the interest in Swedenborg's theology, which is particularly congenial in contrast to the fire-and-brimstone railings of many Christian religions. There are heavens and hells (notice the plural), comprising communities of like-minded individuals, but no spirit is granted heaven or condemned to hell; rather, each spirit *chooses* his or her own final destination after a period of "soul searching," a sort of self-evident judgment in which little by little the true self is revealed. Those of a loving and true heart will be angels; even the weak and sinful can become angels, if they eventually see the errors of their ways, have at basis a loving nature, and acknowledge the new truths they are taught in their

heavenly reeducation. Those who revel in deceit, hatred, and iniquity, however, will become devils and want to be with their own kind (indeed, the sight and smell of angels are offensive to them). In hell, the greatest torture suffered by a devil is his or her all-consuming hatred and jealousy, topped by an overwhelming desire to dominate others. All in all, Swedenborg described a magnanimous and loving God who created heaven for human beings.

Since all human beings are angels-in-waiting, as it were, these beatific beings are of special interest to Swedenborgians. In his heavenly travels—Swedenborg was a mystic who claimed to have daily visited heaven (and hell, with special dispensation) over the last twenty-seven years of his life—Swedenborg's guides were angels, the spirits of deceased human beings who had led good lives and had loving hearts, so they understood life on earth (and were often very amused by it, especially by the misconceptions about the afterlife). Angels are ranked according to their capacity for goodness and wisdom; some remain on a spiritual plane, closer to our world, while the highest are on the celestial plane, closer to God.

All angels work; indeed, one of the great joys of their afterlife existence is their contribution to their angelic societies. All angels have a soul mate, with whom they enjoy complete union (in every sense: mental, spiritual, and physical). Indeed, the angelic being is the apotheosis in vigor and beauty of its twenty-one-year-old mortal self, married to the intellectual acumen and wisdom of the more mature person.

If a child dies, his or her spirit is instructed by angels; the angelic child then grows in life and maturity until he or she reaches adulthood. Likewise, an old man or woman, no matter the suffering in life or the age at death, will "grow"

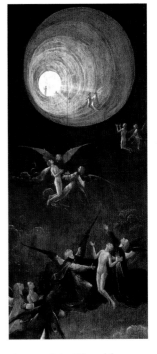

*Ascent of the Blessed* from the polyptych *Visions of the Hereafter* (c. 1490) by Hieronymus Bosch (c. 1450–1516) oil on panel, Doge's Palace, Venice, Italy.

Emanuel Swedenborg
(1688–1772)

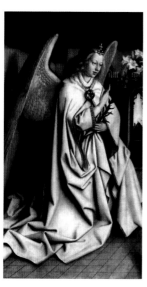

*Angel of the Annunciation* from The Ghent Altarpiece (1432) by Jan van Eyck (c. 1395–1441), oil on panel, Cathedral of Saint Bavo, Ghent, Belgium.

also to youthful perfection, all bodily defects gone without a trace. "Life" in the afterlife, according to Swedenborg, is indeed a full and real one, better in every sense than life on earth.

The book of Revelation has a profound meaning—indeed, a joyful one—to Swedenborgians, in stark contrast to traditional interpretation, especially in popular culture. According to Swedenborgian author and teacher Anita Dole, "The book of Revelation has been called 'the charter for the New Church' because it prophesies its establishment." She also characterizes Revelation as "the culmination of human history, the final act in the great drama of man's spiritual development both as a race and as an individual."[4]

In the final decades of his life, Swedenborg concentrated on biblical exegesis, a line-by-line, often word-by-word, analysis of what he called the inner meaning of the Bible. While he acknowledged a "natural," historical background to the Bible, he believed that he had been called on by God to reveal to the world the "spiritual," hidden meaning, the arcana that revealed the true meaning of the symbols and incidents described in the text. From this interpretation, the world would be privy to divine truths that show the progression of humankind from paganism and idolatry to the true Christian religion.

From a Swedenborgian perspective, then, the Bible could be read as an allegory describing the spiritual regeneration of the human being. For example, some biblical scholars have regarded the seven stars and seven lampstands of the book of Revelation as symbolic of the seven stages of the Christian church. Swedenborg, however, sees the seven churches as representing either types of people or individuals who are practicing Christians with the capacity to work on their faults

and become a part of the New Church (the new spiritual age that is predicted in Revelation). Swedenborg sees in each of the seven types strengths and flaws in belief and practice; thus, each "church" represents a part of the entirety of the New Jerusalem, the modern dispensation of true enlightenment. Each angel represented in the windows is the apotheosis of a regenerated Christian, a person who, according to the epistle to his or her church, overcame faults and remained true to the highest good that the church represents. In addition, each angel represents a type of individual and also a stage of spiritual growth, reminding us of the paradox that we are loved by God just the way we are and yet are called into greater spiritual development to become the most heavenly person that we choose to be.

It is not known whether any "directions"— perhaps better thought of as suggestions, given Tiffany's supreme confidence in his art—were sent to Tiffany for the composition of these windows; certainly, none has been found in existing records. However, it is not a stretch to think that the commissioning Glendale church would have suggested appropriate presentation based on the writings of the Swedish seer. Swedenborg had written of the hidden, interior meaning of the book of Revelation in two works. The earlier *Apocalypse Explained* is a remarkable explanation of the New Testament's final book. Written over the period 1758–59 but first published posthumously in four volumes (1785–89), the work was never completed, going only as far as Revelation 19. In its longest incarnation, the work was published in six volumes.[5] Another work published during Swedenborg's lifetime (1766) interprets the entirety of the book of Revelation; this work, *Revelation Unveiled* (also

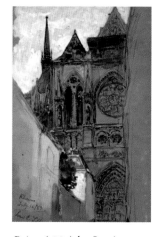

*Reims* (1889) by Louis Comfort Tiffany, watercolor and graphite, Yale University Art Gallery, gift of Louise Platt. In addition to glass, Tiffany explored texture and luminosity in watercolor and jewelry making.

*The Last Judgment* from *The Nuremberg Chronicle*, f265v (1493) hand-colored engraving, Institute for Brazilian Studies—Lamego Collection. Swedenborg writes that the Last Judgment already occurred in 1757 in heaven. There is no coming final battle pitting Christ against the Antichrist, nor will anyone be tried and judged.

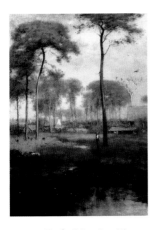

*Early Morning Tarpon Springs* (1892) by George Inness, oil on canvas, Art Institute of Chicago. Tiffany studied painting under Inness in New York City as a young artist.

published as *Apocalypse Revealed*), was the last of Swedenborg's works published anonymously (by a "Servant of the Lord").[6]

Therefore, the windows themselves can be seen as revealing the hidden meaning of Revelation from a Swedenborgian perspective. The Apocalypse is not to be feared; there is no coming final battle pitting Christ against the Antichrist, nor will anyone be tried and judged. Why not? Because the Last Judgment has already taken place—in the heavens in the year 1757, an event Swedenborg said he was privileged to witness.[7] From this idea can be extrapolated a symbolic view of the angelic windows that is more concerned with spiritual regeneration in this life than prophesying a war between good and evil at the end of time. This may explain—at least, in part—why the angels from Revelation in these windows appear intelligent and peaceful rather than the vengeful, militant, and terrifying creatures often associated with the Apocalypse.

Finally, Swedenborg's method of exegesis was Neoplatonic; he saw in all natural things, from the smallest stone to the shining sun, a correspondence with the truth behind the image, the outer form being merely a symbolic representation of a deeper spiritual meaning. His so-called theory of correspondences reveals a wondrous world of hidden ideas. This adds another layer to the interpretation of the windows: each color in the glass, each piece of clothing, each object held or displayed has a special meaning, which Swedenborg exhaustively explained in his many writings.[8] And the windows themselves, as works of art that are most beautiful when we see the transmission of light through the stained glass, exemplify by correspondence the beauty of the way God works

through the agency of human beings—when people live beautiful lives and bring about joy in the world.

Did Louis Comfort Tiffany (1848–1933) know any of this? Tiffany was not a Swedenborgian, although, given the times, he probably would have had a passing knowledge of Swedenborg's ideas. His first teacher was a Swedenborgian, the painter George Inness, but there is no indication that Inness shared his beliefs with Tiffany.[9] What Tiffany did believe in was glass and color. Author Hugh F. McKean recounts the haunting impression that the rose windows of Chartres Cathedral had on the young Tiffany when he first saw it at the age of seventeen; as Tiffany later wrote, "I was attracted to the old glass in windows of the Twelfth and Thirteenth Centuries which have always seemed to me the finest ever. Their rich tones are due in part to the use of pot metal full of impurities, and in part to the uneven thickness of the glass, but still more because the glassmakers of that day abstained from the use of paint."[10] In the 1870s, Tiffany began to experiment with color and glass. Soon he was creating full-size "paintings" in glass, windows that exhibited the human form.

In addition to art, Tiffany was devoted to business. If Swedenborgianism was at its height at the turn of the twentieth century, so was Tiffany's enterprise, the Tiffany Glass & Decorating Company. Although most people today associate Tiffany's work with lamps, by far the primary occupation of his business was the construction of full-length windows—in particular, church windows with biblical themes.[11] The last quarter of nineteenth century saw a boom in the construction of churches, as a renewed religious fervor swept the country; and Tiffany, his

GEORGE INNESS (1825–94) An American landscape painter influenced by the writings of Swedenborg, in particular his theory of correspondences. Inness's panoramic agrarian scenes often feature heavy clouds and brooding skies. Much of his later work was produced in the studio, painted from memory rather than direct observation. According to Inness, "The true use of art is, first, to cultivate the artist's own spiritual nature."

Western façade rose window, Chartres Cathedral (constructed 1193–1250). Tiffany was inspired by the rich colors and textures of the stained glass windows of the twelfth and thirteenth centuries, especially the rose windows at Chartres.

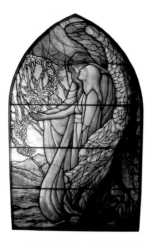

*Guiding Angel* (c. 1890), Tiffany Glass & Decorating Company, Richard H. Driehaus Gallery of Stained Glass, Chicago, Illinois. The primary occupation of the company was the production of full-length windows with biblical scenes. Its success coincided with the fervent religious activity in the United States in the late 1800s.

reputation solidly established as the leading artist in glass, was in place to take full advantage of the demand. One Tiffany scholar states that "there are literally *thousands* of his windows throughout the United States, many tucked quietly away in towns as remote as Ypsilanti in Michigan and Yazoo City in Mississippi. Even allowing for the fact that Tiffany's business spanned fifty years, the quantity is astounding. . . . The vast majority of the firm's work was ecclesiastical. Its growth coincided with, and came, finally, to depend upon, the feverish religious activity in the United States in the late 1800s."[12]

Thus, Tiffany windows were not unique to any church during this period, although they certainly were prestigious. Angels and the Bible were perfect for Tiffany's talents, so the Swedenborgian commission would seem like a natural outgrowth, given the importance Swedenborg assigned to both. The pages that follow offer an interpretation of the special Swedenborgian meaning of the angel windows, although not the only one possible. The descriptions of the "types" of people represented by each church are taken directly from Swedenborg's *Revelation Unveiled.* In particular, to understand the spiritual symbolism from a Swedenborgian perspective, it is important to understand what the meaning of each type is and why that person's good and bad points need to be emphasized or reformed, respectively.

The interpretations for each personality type are also based on a wonderful nineteenth-century work written by a Swedenborg scholar, William Bruce. Bruce's *A Commentary on the Revelation of St. John,* written in a florid, Victorian English, has purpose and effect. In a charming preface, Bruce writes that his reason for undertaking the book was to show New

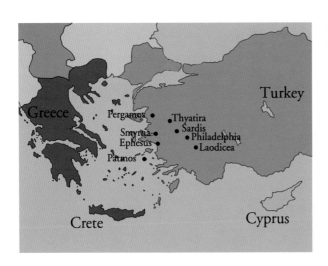

Map of the seven churches of the book of Revelation.

Churchmen (that is, followers of Swedenborg's writings who, after his death, founded a church) the importance of Revelation in everyday living. The result of Bruce's "labours" is a 458-page exegesis of Swedenborg's meaning, applied to everyday life, so that all people can become the angels God intends them to be. Another insightful book about the spiritual meaning of the seven letters to the seven churches is *Landmarks in Regeneration* by Douglas Taylor, a Swedenborgian minister. Written in modern English, and therefore more easily accessible than Bruce's work, Taylor's book provides clarification of the symbology of the angels.

The seven angels of the seven churches come at the beginning of the book of Revelation, almost as if they were a reminder of the seven days of creation that begin the book of Genesis. Swedenborg frequently wrote that there is an order to our lives that we can observe when we have the intention of using our insights to further spiritual growth in ourselves and others. In the seven days of creation, we are given a description of what earthly life comprises and, in the seven angels of the churches, we are given the possible outcomes of the lives we lead, as individuals and as communities, in the process of spiritual growth that bring us to the doorway of the life beyond life. ✤

# The Angel of Ephesus

To him that overcometh
will I give to eat
from the tree of life,
which is in the midst of
the paradise of God

*To the angel of the church in Ephesus write: These are
the words of him who holds the seven stars in his right
hand, who walks among the seven golden lampstands:
    I know your works, your toil and your patient endur-
ance. I know that you cannot tolerate evildoers; you
have tested those who claim to be apostles but are not,
and have found them to be false. I also know that you
are enduring patiently and bearing up for the sake of
my name, and that you have not grown weary. But I
have this against you, that you have abandoned the love
that you had at first. Remember then from what you
have fallen; repent, and do the works you did at first.
If not, I will come to you and remove your lampstand
from its place, unless you repent. Yet this is to your
credit: you hate the works of the Nicolaitans, which I
also hate. Let anyone who has an ear listen to what the
Spirit is saying to the churches. To everyone who con-
quers, I will give permission to eat from the tree of life
that is in the paradise of God. —*Revelation 2:1–7

**Physical
Description**
The first angel, Ephesus, gazes serenely at us,
a radiant female face surrounded by the fiery
golden halo of her wings and backed by the
azure blue of the evening sky in which a bright
star shines down upon her. In her right hand,
she holds a branch of the Tree of Life. The angel
wears opalescent armor scrolled with vines,
a continuation of the natural imagery motif
of this window. A diadem with a bright yel-
low jewel crowns her head. Her upper body is
sheathed in amber drapery, while the rest of her

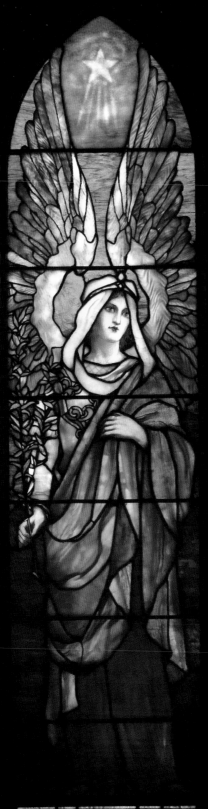

EPHESUS

To him that overcometh
will I give to eat of the tree
of life, which is in the midst
of the paradise of God.
Rev. II.

body, indeed the bottom third of the window, is shadowed in deepening tints of blue. The effect is to concentrate the light on the angel's countenance, somber and peaceful.

This window showcases some of the special features of Tiffany's Swedenborgian angel windows, while also being unique among them. The use of "drapery glass," which added a three-dimensional texture to the flow of outer garments, was Tiffany's own invention.[1] The layering of several sheets of colored glass in differing translucencies creates the effect of ripples, shadows, and natural lines for the angel's robes. It especially simulated the dress of biblical figures, who comprised most of Tiffany's human images in windows.

The Swedenborgian angels, unlike other angels in Tiffany's ecclesiastical settings, are not in motion; they do not descend from on high or hover in midair. These are firmly planted in position, adding to their solidity as figures of hope and as figures of fulfilled promise.

Another common feature of the windows that is first encountered in the angel of Ephesus is the red wings forming a golden halo around the angel's head and the luminescent star at the top of the window. Shafts of light radiate from the star, symbolizing the angel's role as a guide through the darkness.

Lastly, the Ephesian window is the only one of the set of seven to have a floral motif. While human figures were prominent in Tiffany's church windows and also in funerary windows for private memorials, he is best known for his brilliantly colored, exquisitely rendered natural landscapes depicting flowers and plants. Here is an unobtrusive branch without blooms or even buds, whose herb-like leaves seem to intertwine with the scrollwork of the angel's armor.

This window stands out from the rest in that it is distinctly feminine, even maternal, while the others appear largely androgynous, sometimes more masculine than feminine, but rarely definite in gender. The angel of Ephesus appears older than the rest and is the least adorned, with only a small band encircling her head covering, topped by a single yellow stone. She is also one of the two darkest-tinted windows in the set.

## GEOGRAPHICAL SETTING

The physical location of the city of Ephesus is today near the town of Selçuk, Izmir Province, in Turkey. In the first century CE, it was the second-largest Roman city and was the seat of Roman power in Asia Minor. It was a major seaport, the first stop a traveler from Rome would make in the Roman Asiatic provinces. It was also the beginning of the postal route, which may be why John chose these seven cities for his epistle.[2]

The church at Ephesus was established by Paul, the apostle to the gentiles, in the first century, circa 55 CE. At the time that the book of Revelation was written, Ephesus was important because of its location, commercial opportunities, and vast population. A bustling city

Remains of the Temple of Artemis in Ephesus last rebuilt in 323 CE. The Greek temple dedicated to the goddess Artemis was one of the Seven Wonders of the Ancient World. In 401 CE, a group of Christians destroyed the temple completely, encouraged by the words of the bishop of Ephesus, St. John Chrysostom. All that remains today are parts of the foundation and fragments of sculptural details.

of approximately 250,000 inhabitants, Ephesus had strong links to ancient Athens, was the site of the Temple of Artemis, and boasted the world's largest amphitheater, seating twenty-five thousand.[3]

At that time, the church of Ephesus faced a danger from without—the power of the Roman state—and from within, the Nicolaitan "Christians" who believed that compromise with the pagan religions of the city was permissible, even commendable (see below). These are the battles—both physical and spiritual—represented by Ephesus.

## BIBLICAL MEANING

(ABOVE)
*Artemis of Ephesus,* marble and bronze, Roman copy of a Hellenistic original from the second century BC, Albani Collection, Palazzo dei Conservatori, Capitoline Museum, Rome, Italy. In Greek myth, the virgin moon goddess Artemis is the twin of the sun god Apollo. A cult statue of her was kept at her temple in Ephesus and decorated with jewelry. The distinctive feature of the Ephesian Artemis is her many breasts, symbolizing fertility.

There are many interpretations of the book of Revelation, especially in popular imagination. Traditionally, biblical scholars have viewed the seven churches as symbols of the seven stages of Christianity, beginning with its inception and ending with Christ's Second Coming.

Ephesus in this reading may be regarded as the first, "apostolic" church in its doctrinal purity and enthusiastic acceptance of the new dispensation—the first joy of discovery and understanding. Yet, according to John's epistle, it seems that this initial feeling had been in some way lessened. Perhaps the congregation, living in the greatest city of Asia Minor, had become complacent, and such complacency signaled the diminishment of the Christian movement.

John's words to the community come from "him who holds the seven stars in his right hand, who walks among the seven golden lampstands" (Rev. 2:1), the stars signifying the seven angels and lampstands the seven churches, as revealed in the previous verse. The Ephesians are praised for their hard work, patient endurance, and abhorrence of false apostles; in particular,

John found that the true Christians of Ephesus "hate the works of the Nicolaitans, which I also hate" (Rev. 2:6). Little is known with certainty about the Nicolaitans, although they appear or are alluded to in other of Revelation's epistles; they are believed, however, to have been part of the Christian community, a group who favored tolerance of other religions, arguing that Christians could sacrifice to the emperor for safety's sake, since the sacrifice would be only a gesture of convenience, not a matter of true belief.[4]

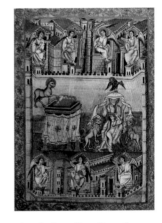

*Angels Standing Guard over the Seven Churches of Asia.* Frontispiece for the book of Revelation from the Bible of San Paolo fuori le Mura (c. 870), the Papal Basilica of Saint Paul Outside the Walls, Rome, Italy. The "church" represents the living congregation, the spirit of love, faith, and community that sustains believers.

But the Ephesians' rejection of this approach meant that the church at Ephesus was a strong center, one that could withstand the ever-present, sometimes overwhelming pagan influence. Despite this, they were found wanting: ". . . you have abandoned the love you had at first" (Rev. 2:4). They must repent of their failure and rectify their ways in order to achieve salvation, as represented by the Tree of Life. If they fail to recover their initial enthusiasm, they are threatened with the lost of their lampstand, their church.

It is not, of course, a building that will fall or another that will not be built. The "church" represents the living congregation, the spirit of love, faith, and community that sustains believers. The Christian community at Ephesus was in danger of losing the light of its faith, its fire, and its brilliance. But all was not lost; the Spirit promises that everyone who strives to regain the new bloom of her faith will eat from the Tree of Life, the traditional biblical symbol of immortality.

*The Vision of the Seven Candlesticks* from the Ottheinrich Bible f284v (c. 1530) by Matthais Gerung (1500–70), Bavarian State Library.

## SPIRITUAL SENSE

Remembering that these windows were commissioned especially for a Swedenborgian church by another Swedenborgian church, it is reasonable to assume that the windows contain a spiritual

*John Writes to the Churches of Ephesus and Smyrna* from the Bamberg Apocalypse f4v (c. 1000), Bamberg State Library, Bavaria, Germany. According to Swedenborg, the seven churches of Asia represent every person who is receptive to the light of truth and the good that comes of it. The church of Ephesus is not only a building, but a spiritual state.

*All of us focus on theological truths in the first place, but as long as we do we are like unripe fruit. If our regeneration has started, though, once we have absorbed these truths we focus in the first place on living a good life. To the extent that we do, we ripen like fruit, and to the extent that we ripen the seed within us becomes fertile.* —Revelation Unveiled §84

meaning. Indeed, Swedenborg devoted two series of books to explaining the book of Revelation: *Apocalypse Explained* (six volumes, though unpublished in his lifetime) and *Revelation Unveiled* (two volumes, also published as *Apocalypse Revealed* ).

What does Swedenborg tell us about the significance of the seven churches and the seven angels? The seven churches of Asia represent every person who is receptive to the light of truth and the good that comes from it—in other words, all people who allow God to come into their hearts and who strive to make a daily practice of following this wisdom. The seven angels represent different types of human beings who are working their way to an eternal destiny, living their lives as best they can. Each type has a particular strength and a particular flaw. But these angels also represent the essence of a particular stage of a person's spiritual development; no matter which angel resonates most with an individual's personality, they all speak to a part of us at certain times in our spiritual lives. Each window tells a story of the challenges and joys of a particular stage along the path and describes the actions needed for bringing about a joyful existence during that stage.

Therefore, the church of Ephesus can be seen not only as a brick-and-mortar building or a specific group of people who lived two thousand years ago, but also as a spiritual state. The angel representing the church of Ephesus praises people who work hard to deepen and express their faith but also contains a warning: do not forget the love of God that inspired that faith in the first place. The church of Ephesus represents the dangers of focusing on rigid doctrine while ignoring goodness and love, or having pride in one's achievements while ignoring the needs

of others and the source of divine inspiration. Goodness comes from performing loving acts from a deep sense of humility and love of God. The challenge Ephesus represents is that of holding on to a teaching or belief so strongly that you forget its most important essence, which is love. John says that the Ephesians will attain salvation if they return to their "first love."

*If issues of doctrinal truth are put first or made our primary focus, we may then gather true information, but without depth of insight and without loving this truth with a spiritual affection. The result is that the truths gradually die.* —REVELATION UNVEILED §85

When we look at the windows, we see Tiffany's artistry, in particular his astonishing use of color. Swedenborg's theory of correspondences—that is, the teaching that each aspect of the natural world has a spiritual meaning—endows each window with added significance in regard to color also. The primary meaning of the epistle to the Ephesians concerns the nature and source of truth. In Swedenborg's system, the primary colors of this window—the glowing white and the shimmering amber—stand for the truth and "external divine sphere of the Word," respectively.[5] The golden stone in the angel's diadem represents spiritual goodness, so that the composite effect of the window, in Swedenborgian terms, stresses seeking after spiritual truth and goodness.

But the most important symbol in the window is the Tree of Life, a branch of which is delicately held in the angel's right hand. It is interesting that the branch is somewhat obscure; most of the other symbols held by the angels of the seven churches glow with a radiant light that seems almost supernatural. (The closed book held by the angel of Philadelphia is similarly dark.) The branch is straight and sturdy, yet appears to be light; the angel holds it with only two fingers. It blends in with the darkening blue of the background sky and with the

## SPIRITUAL MEANING OF THE DETAILS

curling scrolls of the angel's breastplate, but its fresh green stands out against the bright red of the wings.

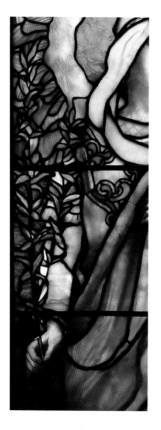

The Tree of Life, of course, has a long biblical and cultural history, mentioned first in Genesis (2:9) and found in many of the world's religious traditions from Mayan to Norse. Everlasting life is given to anyone who eats from the fruit of this tree.[6] Swedenborg interprets the Tree of Life as the Lord, signifying love. So, to eat from the Tree of Life means that a person receives love from the highest source (*Revelation Unveiled* §89).

In essence, then, the angel of Ephesus, as depicted in Tiffany's window, represents a completed person. Intellectually curious, always seeking divine truth and acknowledging that all knowledge comes from heaven, she shows no pride in knowing or proclaiming doctrine because she accepts that such knowledge proceeds from a greater source for a greater purpose. Her knowledge has been tempered by the greater gift from heaven: love.

ANGELIC WISDOM    What we learn from Ephesus—both the angel and the state of spiritual development—is how easy it is to become rigid in the security of belief systems and forget the motivation for following a particular path. The people of Ephesus are steadfast, loyal workers operating under strict rules but finding no joy in their toil. They feel disconnected from anything greater than self.

The letter to Ephesus directs them (and us all) to return to our first love in order to express our new wisdom as fully alive and spiritually conscious beings.

The angel of Ephesus brings awareness to the spiritual and celestial clothing we are

donning—in the language we choose in our expressions, thought, letters, speech, and all our utterances. The angel brings spiritual awareness to the material knowledge the people of Ephesus received as the first Christian church. They, and we, need to return to the love and good works that motivated them in the beginning.

People can become lifeless in their faith by focusing more on rules or doctrines than on loving service to others. They forget that form is not the essence of a religion. This letter warns against the risk of separating truth from its companion of love and good works, of becoming misaligned with divine purpose. From the stained glass window, we see the angel of Ephesus radiating a serene state of peace and serving as an example of one who expresses both love and wisdom. In her hand she holds the Tree of Life, representing eternal salvation. She represents the highest expression of this spiritual state. ✤

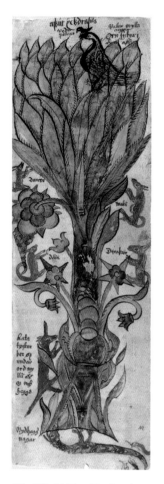

*The World Tree Yggdrasil* from the Edda oblongata (c. 1680), Árni Magnússon Institute, Reykjavik, Iceland.

**PRAYER**

# The Angel of Smyrna

BE THOU FAITHFUL UNTO
DEATH, AND I WILL GIVE THEE
A CROWN OF LIFE

*And to the angel of the church in Smyrna write: These are the words of the first and the last, who was dead and came to life:*

*I know your affliction and your poverty, even though you are rich. I know the slander on the part of those who say they are Jews and are not, but are a synagogue of Satan. Do not fear what you are about to suffer. Beware, the devil is about to throw some of you into prison so that you may be tested, and for ten days you will have affliction. Be faithful unto death, and I will give you the crown of life. Let anyone who has an ear listen to what the Spirit is saying to the churches. Whoever conquers will not be harmed by the second death.*
—REVELATION 2:8–11

**PHYSICAL DESCRIPTION** Smiling beneath a shining star and enigmatically brilliant red wings is a youthful figure in a flowing white mantle: the second angel, the angel of the church of Smyrna. The crimson of the angel's undergarment and its gold embroidery complement the red wings that are the glory of all the angels.

The brightness of this angel contrasts with the subdued hues of the Ephesian angel, as does Smyrna's much more youthful appearance. The angel of Smyrna has golden hair and wears a gold diadem, but most importantly, the angel carries a golden crown that appears to be lit from within. Tiffany accomplished this brightness by using yellow glass and copper foil

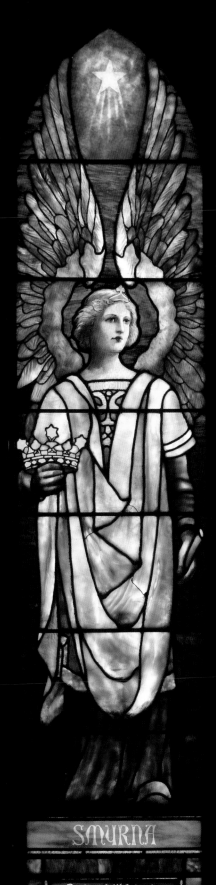

SMYRNA

Be thou faithful unto
death, and I will give
thee a crown of life.
✠ ✠ ✠ ✠ ✠ ✠ ✠
Rev ii:10

and putting chunk glass in the diadem surrounding the angel's hair.[1] The angel radiates a sense of goodness.

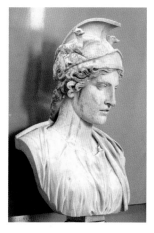

*Bust of Roma.* Roma was a goddess who personified the Roman state. Smyrna was home to one of the earliest known cults to the goddess, established to mark the city's alliance with Rome against the Seleucid Empire in the second century BC.

The historical Smyrna was originally founded around 1000 BCE as a Greek colony in Asia Minor. It was destroyed in 600 BCE by the Anatolian kingdom of Lydia and lay fallow until 290 BCE, when it was refounded by Lysimachus, one of Alexander the Great's generals.[2] Being a faithful and strong ally was a hallmark of the city. When, at the beginning of the second century BCE, the city aligned itself politically with Rome, the city leaders went so far as to create a cult to the goddess Roma. Smyrna remained loyal to Rome through many crises.

It was also a beautiful city, and the trope "crown of Smyrna," referring to a "diadem of porticoes surrounding her hilltop," was well known in the ancient world.[3] So, Revelation's words "be faithful until death, and I will give you the crown of life" would have resonated on several levels with first-century listeners.[4]

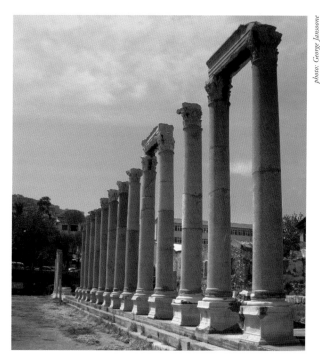

photo: George Jansoone

View of the Agora, columns on the western Stoa in Smyrna. The "crown of Smyrna" refers to a diadem of porticoes surrounding her hilltop. The promise of the "crown of life" would have resonated with the people of the city.

This church, represented by Smyrna, is being warned of an attack that will come. The people will be tested and slandered by "those who say that they are Jews and are not, but are a synagogue of Satan" (Rev. 2:9). Suffering and persecution will ensue, but the people are encouraged to remain faithful until the end, and they will be given the "crown of life" (Rev. 2:10).

The letter to the church in Smyrna is often seen by biblical scholars as friendly; although persecution is predicted, it is foretold that the suffering will be relatively brief (signified by a reference to "ten days" of affliction in Revelation 2:10), and those who persevere will be rewarded with eternal life. The faults of the church are not dwelt on; rather, it is "rich" in faith and perseverance, despite attacks and slanders. One scholar finds the letter so reassuring that he states that the writer "foresaw permanence, stability, reality surpassing the outward appearance, life maintaining itself strong, unmoved amid trial and apparent death."[5]

## BIBLICAL MEANING

*Gold Laurel Wreath*
3rd–4th century BC, probably from Cyprus, Reiss-Engelhorn Museum, Mannheim, Germany. In ancient Greece, the laurel tree symbolized moral purification and atonement, and the sun god Apollo was often depicted wearing a laurel wreath. In ancient Rome, the laurel wreath was a sign of victory, and its rounded shape represented perfection.

## SPIRITUAL SENSE

Swedenborg sees the Smyrnians as being in a better position than the Ephesians; indeed, Smyrna represents a type of person who is the opposite of the Ephesians. The first church in Revelation represents the person who thinks about doctrine intellectually. He actively seeks truth, studies it, and values it for its insights but doesn't love it or gratefully acknowledge its source. The second church represents the person who doesn't seek knowledge and truth; rather, this person cherishes goodness above all. While one may seem preferable to the other depending on one's disposition, neither is complete without the other. We all have our own personalities: some prefer to understand a truth

*In heaven, the divine nature that emanates from the Lord is called divine truth . . . This divine truth flows into heaven from the Lord, out of his divine love. Divine love and the divine truth that derives from it are like the sun's fire and the light that comes from it in our world. The love is like the sun's fire, and the derivative truth is like the light from the sun.* —HEAVEN AND HELL §13

intellectually, while others find that accepting something that "feels" right or true is good. We do not have to change our true loves or natures; rather, we are asked to look at our deficits and strive to achieve balance.

The person represented by Smyrna is on the whole in a better position than the person represented by Ephesus because, from a Swedenborgian perspective, love is superior to wisdom. Still, the marriage of love and wisdom is our spiritual goal, so we should be striving to join the two qualities. In *Heaven and Hell,* his best-known work, Swedenborg explains that heaven proceeds from the Lord, who is the essence of divine love and wisdom (§13).

When love and truth are united as closely as they can be on this earth, the person reflects a perfect union in the celestial heaven; it is, as it were, a marriage of love and wisdom.

So, a love of goodness or being charitable toward others is only one side of a complete personality. What happens, according to Swedenborg, when the other side, the love of truth, is neglected?

The Smyrnians' love of goodness is sincere but not absolute because it isn't allied to truth—thus, the reference in Revelation 2:9 to poverty and richness. They are rich in love and goodness, but poor in doctrine, so liable to be taken in by doctrines that claim to be true but are not. Swedenborg explains the phrase "those who say they are Jews and are not" in this way:

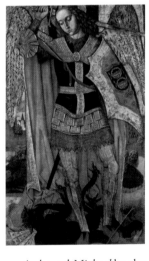

*Archangel Michael* by the Master of Castelsardo, 16th century, Diocesan Museum of Castelsardo, Sardinia, Italy. False ideas plant seeds of doubt and cause a struggle between the angelic and satanic sides of our natures.

> *Jews* does not mean Jews but anyone who is attentive to the good that love does, and in an abstract sense simply the good that love does. So *the blasphemy of those who say they are Jews but are not* means the false claim that they are focused on the good

things love does when in fact they are not. (*Revelation Unveiled* §96)

In Swedenborg's explanation, the term "Jews" signifies people who receive love directly from the Lord, which is one of the highest phases of human development. Those masquerading as Jews are people who spread false doctrine. Because they do not value knowledge and truth, the Smyrnians are in danger of accepting evil precepts that are presented as good; they don't look inward to understand truth, so they cannot separate the real from the false. The Ephesians, on the other hand, who value intellectual doctrine above all else, "have tested those who claim to be apostles but are not, and have found them to be false" (Rev. 2:2).

The suffering alluded to in Revelation 2:10 is the period of regeneration, or spiritual rebirth, that this type of person must undergo in order to cleanse his mind of false perceptions. It will be a time of combat:

*Temptation of Adam and Eve* from the Pasionál abatyše Kunhuty, 14th century. By experiencing spiritual temptation, we clarify our thinking, examine our motives, and choose which path we will follow, which voice we will listen to.

> [A]ll spiritual testing is a battle between the Devil and the Lord as to who will have control. The Devil or hell brings out its falsities and threatens and condemns, while the Lord brings out truths, leads out of falsities, and liberates. This is a battle that seems to be within us because it comes from the spiritual evils that are associated with us, and it is called "temptation." (*Revelation Unveiled* §100)

Temptation lasts for a lifetime; it is not a short-term struggle. In Swedenborg's understanding, unlike that of most biblical scholars, being tested for the "ten days" mentioned in Revelation indicates enduring the state of temptation to the fullest.

In the end, however, the person represented by Smyrna, should he or she see the failing and

fight against the temptation, will be crowned with victory. As William Bruce describes it, "he who resists the evil loves and false persuasions of the natural mind, and overcomes the temptations which would lead him to submit to their domination, will for ever, not only be free from their power, but will hold them in subjection."[6]

SPIRITUAL MEANING OF THE DETAILS

The angel of Smyrna represents a person who combines love and truth, as can be seen in the window's predominant colors. White in Swedenborg's correspondence represents truth, while gold signifies the good of love from the Lord (*Revelation Unveiled* §912).[7] The red robe under the white drape represents love, the motivating force for the people of Smyrna underlying all of their actions.

The main symbol, the crown of life, glows in the yellow glass, topped with golden stars, which represent the knowledge of truth and good. The crown is a victory wreath, a victory of truth over falsity. In Swedenborgian terms, the window encapsulates the marriage of good and truth, love and wisdom.

ANGELIC WISDOM

Smyrna as a spiritual state describes one who loves to do good and is loving and kind but is influenced by false ideas. It describes those whose desire to do good works exceeds their own levels of wisdom and understanding, allowing false ideas to creep in when the guard of discernment is down.

These false ideas plant seeds of doubt and cause a struggle to ensue—a struggle between the angelic and the satanic sides of our natures. The desire to do things primarily for one's self

may struggle with the more generous side of a person's nature, resulting in anxiety, confusion, and anger or depression. This is called a spiritual temptation, and it is by going through these that we clarify our thinking, examine our motives, and choose which path we will follow, which voice we will listen to.

If people do good things for the wrong reasons, it is only an external good, not a spiritual one. It looks good on the outside, but is not done with the full understanding or acknowledgment of the source of this good. If people attribute all good thoughts and actions to themselves, they very quickly are cut off from the source. That is what has happened to the people of Smyrna.

A person in the spiritual state represented by Smyrna is instructed to endure these spiritual tests until the end and is promised that the reward is eternal salvation, pictured as the crown of life. If we remain faithful through the first death or physical death, we will be saved from the second death, which is a spiritual death or damnation. By facing the challenges we are given and staying true to the knowledge of the source of all good, we can stay in alignment with the divine, thereby earning the right to the crown of life and life everlasting. ✤

*People think that there is no element of truth or falsity in the good that we do; and yet there is no other source of the quality of the good. They go together like love and wisdom—like love and stupidity, too. The love of someone who is wise is a love that does good, while the love of someone who is stupid does what looks the same outwardly but is radically different inwardly. This is because the good done by someone who is wise is like pure gold while the good done by someone stupid is like gold-plated dung.*
—Revelation Unveiled §97

*Lord, grant me the wisdom to
hear your words clearly.
Teach me to listen carefully and love wisely.
Clarify my thoughts and examine my motives
so that all good that I do comes through wisdom
and is freely given to further
the good of the recipient.
In this way, please allow me to be
a clear and open channel for your love.
Amen*

PRAYER

# The Angel of Pergamos

To him that overcometh
will I give a white stone
and in the stone a new
name written

*And to the angel of the church in Pergamum write:
These are the words of him who has the sharp two-edged sword:
    I know where you are living, where Satan's throne
is. Yet you are holding fast to my name, and you did
not deny your faith in me even in the days of Antipas
my witness, my faithful one, who was killed among
you, where Satan lives. But I have a few things against
you: you have some there who hold to the teaching of
Balaam, who taught Balak to put a stumbling block
before the people of Israel, so they would eat food
sacrificed to idols and practice fornication. So you also
have some who hold to the teaching of the Nicolaitans.
Repent then. If not, I will come to you soon and make
war against them with the sword of my mouth. Let any-
one who has an ear listen to what the Spirit is saying to
the churches. To everyone who conquers I will give some
of the hidden manna, and I will give a white stone,
and on the white stone is written a new name that no
one knows except the one who receives it.* —Revelation
2:12–17

**Physical Description**

The third angel is Pergamos, whose name comes
from Pergamum, a city in Asia Minor. It is the
most masculine of all the angels, compared with
Ephesus, who is the most feminine. The angel
is dressed in the clothes of a warrior, complete
with golden body armor and a shield held in his
left hand. Under the star and red wings that are
a constant throughout all seven windows, Perga-
mos is dressed in a golden tunic with green and
yellow jewels as a clasp for his robe and around

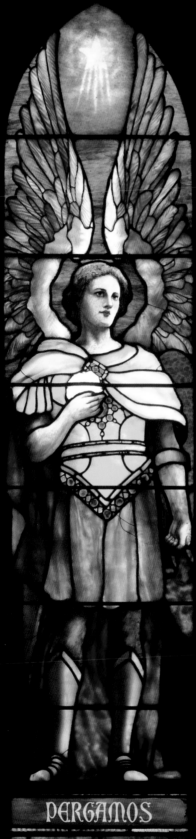

PERGAMOS

To him that overcometh
will I give a white stone
and in the stone a new
name written. + +
Rev ii 17

its borders. The focus of the window is the large, brilliant white stone held in his right hand, which protrudes from the surface of the window. The lining of the cloak—a strong red—sets off the golden, opalescent drapery glass of the outer layer.

GEOGRAPHICAL SETTING

Pergamum, from which the angel draws its name, was the central city in Roman Asia Minor, though at the time of the writing of Revelation, it was ceding its dominance to Ephesus.[1] The city was "owned" by Rome; it had been bequeathed to Rome in 133 BCE by Attalus III, who died without an heir. According to W. M. Ramsay, it was a cosmopolitan center, displaying Hellenic and Asiatic influences; the four patron deities of the city were Zeus, Athena, Dionysus, and Asclepius. It also was an early center of a ruler cult, not just related to Roman emperors but also to the indigenous kings of the province. The first temple to Augustus was built around 29 BCE.[2]

BIBLICAL MEANING

The letter to the church of Pergamos opens with a more threatening pronouncement than seen so far: "These are the words of him who has the sharp two-edged sword" (Rev. 2:12). It gets even harsher in its warning: the church lives "where Satan's throne is" (Rev. 2:13). Even though many in the church have been faithful to

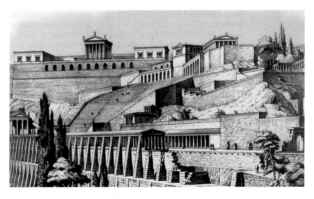

*View of Ancient Pergamon,* 19th century, Pergamon Museum, Berlin, Germany. Nineteenth century German archaeologists excavating the ruins of the ancient city created this drawing that represents an educated speculation as to how the city may have looked.

Christian teachings, there are some "who hold to the teaching of Balaam" (Rev. 2:14) and others "who hold to the teaching of the Nicolaitans" (Rev. 2:15), the group that was also causing dissension in Ephesus. The warning is that if the church does not repent, it will be attacked with the two-edged sword. Those who do repent will be rewarded with "hidden manna" and a white stone on which is written a new name, a secret identity known only to the recipient.

Biblical scholars interpret the harsh indictment of Pergamos as stemming from the many pagan gods worshipped in the city, with a strong reference to the imperial cult. Zeus Soter (Savior) was one of the patrons, and indeed at least two of its kings were called Sotor (Attalus I and Eumenes II, who was also titled "Theos," or "god"), so the blasphemy of calling a king by the honored title of Christ was central to the city's condemnation. Then there was the patron god Asclepius, whose symbol, a snake twined around a rod, had negative biblical associations.

Nor were the trials and temptations of the Christians of Pergamos solely from without. Again, the shadowy Nicolaitans, who may have sanctioned compromise with the pagan cults and practices of official sacrifice to the emperor,[3] are mentioned, as are a new internal threat, those who worship Balaam. The reference to Balaam would have been immediately recognized from the Old Testament book of Numbers, although precisely how the Christians of the first century would have interpreted the reference is not known. Biblical scholar Colin J. Hemer suggests that the reference to Balaam's teaching to Balak was meant to remind readers of the story of the Hebrews' sins with the women of Moab.[4] Balak was the king of Moab, and he asked the magician Balaam to curse the Israelites so that they

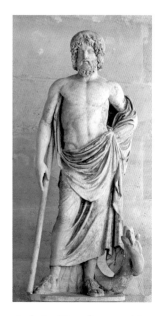

*Asclepios Timotheos,* marble, Roman copy (second century CE) of a Greek original from the fourth century BCE, Louvre Museum. The patron god of Pergamos, Asclepius was the Greek god of medicine and healing, and a son of Apollo.

*Rod of Asclepius.* The symbol of Asclepius was a snake entwined around a staff. The snake is thought to represent the duality of the physician's work in life and death, health and sickness. The snake has negative biblical connotations because of the serpent of Genesis.

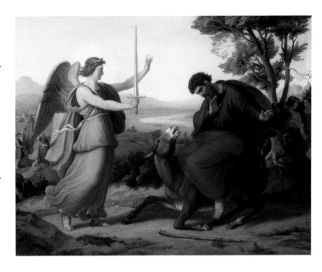

*Bileam und der Engel* (1836) by Gustav Jaeger (1808–71). The story of Balaam occurs at the end of the book of Numbers. He is referred to as a non-Israelite, a diviner and a prophet. Balak, the king of Moab, calls upon Balaam to curse Israel. God is angered by Balaam's actions, and the Angel of Jehovah is sent to prevent his journey. Only the donkey that he rides can see the angel, and it is given the power of speech and complains about Balaam's treatment. The angel then reveals itself to Balaam, who repents, but it allowed to continue his journey to Balak, where his curse turns into a blessing for Israel.

would not attack his kingdom. The Lord turned all Balaam's attempted curses into blessings for the Israelites, and Balaam was forced to leave in failure. But afterward, the Hebrews began to have relations with the women of Moab and make sacrifices to their gods, drawing the Lord's anger. The story, then, is one of followers turning their back on the blessings they've received and lapsing into idolatry.

In addition, biblical scholars have debated the meaning of the white stone and the new name. Some of the possibilities include a jewel; a token of admission or membership; an amulet with a divine name; a token of gladiatorial discharge; the judicial *calculus Minervae,* the casting of a vote of acquittal; and an allusion to initiation into the service of Asclepius.[5] The broad consensus, however, is that the white stone in some way signified membership or freedom.

There have also been several contenders for the meaning of the "new name" mentioned in Revelation 2:17, but it can be seen as signifying a new life or a new identity under a new dispensation. Therefore, scholars see in this letter a church in danger of reverting to paganism and the punishments from God that follow but also themes of repentance and forgiveness.

When we look at the angel of Pergamos as depicted in the Tiffany window, however, we see none of the warnings, the threats from external paganism and internal compromise, or destruction by a double-edged sword. Instead, the Swedenborgian angel of Pergamos stands solidly in military garb, a shield in his left hand while his right clasps to his chest a glowing white stone, which is so luminous that it stands out even against the golden body armor. The young, strong, masculine figure has received the reward, so has overcome the earthly temptations.

Swedenborg saw the church of Pergamos as representing the type of Christian who believes that his or her good deeds are sufficient for salvation. Such Christians may be active but, lacking doctrine and truth, do not understand what their actions signify. He describes them as "images carved out of wood" (*Revelation Unveiled* §107); they are lifeless. Their works are done for merit alone, not from good intentions. Swedenborg interprets Balaam and Balak as hypocrites: Balaam was a diviner who spoke well of the Israelites but advised the Moabite king Balak to destroy them (*Revelation Unveiled* §114). The Nicolaitans signify those who claim merit for their works (*Revelation Unveiled* §§86, 115).

But what is wrong with good works, no matter the intention? Isn't the result more important than the cause? Swedenborg answers this with a resounding no, stating that works cannot be good if they are not secured by truth. This is shown by the inner meaning of the "sharp two-edged sword" that proceeds from the Lord's mouth. As one Swedenborgian scholar explains:

> The sword of the Lord, as the emblem of His Divine truth, indicates to those who think to be saved by works alone that

*In the Word there is frequent mention of swords and daggers and broadswords, and these simply refer to what is true fighting against and destroying what is false, or in an opposite sense, what is false fighting against what is true. Wars in the Word, you see, mean spiritual wars, which are wars of truth against falsity and of falsity against truth; so weapons of war mean what we use to fight the battles of those wars.*
—REVELATION UNVEILED §52

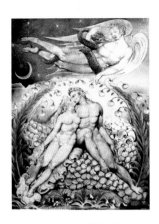

*Satan Watching the Caresses of Adam and Eve* (1808) by William Blake from *Paradise Lost,* pen and watercolor on paper, Museum of Fine Arts, Boston. A "name" indicates the quality of a person or thing. Goodness and truth are not learned from worldly experience, but inscribed in the heart by God.

these are not sufficient; that truth must be combined with good in order to render it genuine; and to show that unless they proceed from a purified will and an enlightened understanding, they cannot bear the strict scrutiny which Divine truth as a penetrating sword will exercise upon them, scattering them by its presence; cutting us asunder, and appointing us a portion with the hypocrites.[6]

Still, Swedenborg tells us that this is a sword of truth, so it cannot be intended solely or even primarily for harm. Rather, it is mainly for protection. Truth protects us from deluding ourselves as to the intention of our actions. The opening line of the letter—"I know where you are living, where Satan's throne is"—indicates that this type of person dwells in spiritual darkness, foolishly believing that his or her charitable actions are enough to warrant an eternal reward. It is not where our body resides that is important but where our spirit resides. If our true desires and motivations are bent toward heaven and truth, our spirit dwells in heaven, even while we live on earth; if not, then our good works are only external, not based in goodness and not destined for a spiritual reward.

But the reward for self-examination and reclamation is great. In Swedenborg's writings, "manna" means a hidden wisdom attained only by those angels in the highest heaven, a wisdom blessed with love. Once again, we see the marriage of good and truth, which was stressed in the first two windows. Swedenborg emphasizes this by stating that the "white stone" indicates "truths favoring and united to good" (*Revelation Unveiled* §121). Once we accept truth in our hearts, our works will proceed from spirit, not from a desire for worldly approbation.

And what is the "new name that no one knows except the one who receives it"? A "name" in Swedenborg's spiritual correspondence indicates the quality of person or thing; here the quality is good united with truth. Its secret relevance known only to the bearer means that goodness and truth are not external—not learned by rote or from worldly experience—but inscribed in the heart by God's grace.

Swedenborg sums up his explanation of the letter to Pergamos thus: "It means, in short, that they will be angels of the third heaven if they read the Word, draw theological truths from it, and turn to the Lord" (*Revelation Unveiled* §123).

The angel depicted in the Tiffany window is an angel of the "third heaven," the highest level of celestial goodness. Recall that angels are not a separate spiritual creation but human beings who aspired to truth and goodness in their earthly life. Angels live in one of two heavenly kingdoms: the lower, spiritual heaven or the higher, celestial heaven. The term "higher" indicates what is deep inside us, and hence closer to the Lord, while the "lower" designates what is external; though both types are angels in good standing, the celestial angels receive love from the Lord wholeheartedly, as it were, and the spiritual angels receive it intellectually. The former is better:

> The angels in the Lord's heavenly king-
> dom far surpass the angels of the spiritual
> kingdom in regard to wisdom and splen-
> dor because they accept the Lord's divine
> nature on a deeper level. They live in love
> for him, and are therefore more intimately
> united to him. The reason for their excel-
> lence is that they have accepted divine
> truths directly into their lives rather than
> taking them into memory and thought
> first, the way that spiritual angels do. This

*The garden planted by Jehovah God on the east in Eden is, in the highest sense, the Lord himself. In the [next] deepest sense (which is also the universal sense), the garden is the Lord's kingdom or heaven, where we are put when we become heavenly.*
—SECRETS OF HEAVEN §99

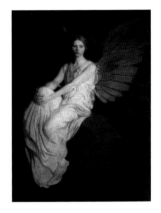

*Stevenson Memorial* (1903) by Abbott Hand-erson Thayer (1849–1921), Smithsonian American Art Museum.

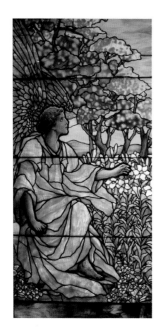

means they have them engraved in their hearts and grasp them, virtually see them, within themselves. They never calculate whether or not they are true. (*Heaven and Hell* §25)

As the most excellent angels are united in truth and goodness, the angel of Pergamos, the human being who once lived on earth and sought to overcome worldly vanity, holds his shield down. In his triumph, there is no need of defense because evil can no longer attack him. Nor has he need of a sword; his pure white stone, held against his heart, is his symbol of victory.

## Spiritual Meaning of the Details

The angel is portrayed as a Roman warrior, not an aggressive one, but one who fights against lies and falsity. The cloak and body armor that cover him are a brilliant golden color, a color representing the highest form of love, love from the Lord. This love shines forth from the angel as his most prominent feature—his protection and his strength. The gold stones decorating the breastplate have a similar meaning; the green stones stand for the ways in which the Lord manifests in the world. More subdued in this window is the cloak's red lining. Red represents love, and specifically the good things that come from love.

The white stone that the angel holds represents truths that come from goodness and love. This stone is given as evidence that the good within the person is united with divine truth, which gives this person a new name or a new quality. We are now witnessing a divine marriage of love and wisdom. This is the highest reward.

*Roman Soldier* from the collection of Emperor Rudolf II, from *The Great Events of World History* by Otto Zierer, 1980. The angel of Pergamos is dressed like a Roman soldier.

The people of Pergamum are good and faithful servants of the Lord, performing loving deeds as an expression of their faith. They are the ones who are there to help a neighbor in distress, ones you can always call on when you need them. They represent anyone who is in this loving spiritual state.

Both these people and this spiritual state have a flaw, however: they do not base their good works on the truth or follow doctrine as an incentive for their good works. They do good because they are good. However, not reading the divine scripture or basing actions on truth leaves us open to the influence of faulty thinking or unclear motivations. It can disconnect us from the knowledge that comes from the source of divine love.

The solution is to become more closely aligned to the sacred through the direct connection of reading the Bible, drawing wisdom from it, and turning our attention upward. Once this happens, the highest heaven is available. Those represented by Pergamos are already in a state of love and need only the truths of universal wisdom to clarify their goodness. Love, no matter how pure and powerful, always needs the balance of wisdom for full and glorious expression. This manna from heaven, love itself, is victorious, and the recipient will forever be changed. The source of all good will be clearer to this person and will shine forth as brightly as the pure white rock the angel holds in his hand. ✦

## ANGELIC WISDOM

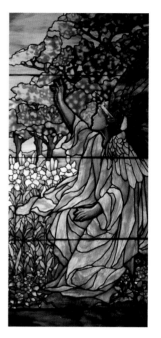

(FACING PAGE AND ABOVE) *Two Angels* by Tiffany Studios, c. 1910, Richard H. Driehaus Gallery of Stained Glass, Chicago.

## PRAYER

*Lord, open my heart to your wisdom
so that it will always be available
to guide and lead me.
Let me follow your way of truth
in spreading love to all of your creation.
In your name always will I do this work.
Amen*

# The Angel of Thyatira

*And to the angel of the church in Thyatira write: These are the words of the Son of God, who has eyes like a flame of fire, and whose feet are like burnished bronze.*

*I know your works—your love, faith, service, and patient endurance. I know that your last works are greater than your first. But I have this against you: you tolerate that woman Jezebel, who calls herself a prophet and is teaching and beguiling my servants to practice fornication and to eat food sacrificed to idols. I gave her time to repent, but she refuses to repent of her fornication. Beware, I am throwing her on a bed, and those who commit adultery with her I am throwing into great distress, unless they repent of her doings; and I will strike her children dead. And all the churches will know that I am the one who searches minds and hearts, and I will give to each of you as your works deserve. But to the rest of you in Thyatira, who do not hold this teaching, who have not learned what some call the "deep things of Satan," to you I say, I do not lay on you any other burden; only hold fast to what you have until I come. To everyone who conquers, and continues to do my works to the end,*

*I give authority over the nations;*
*to rule them with an iron rod,*
*as when clay pots are shattered—*

*even as I also received authority from my Father. To the one who conquers I will also give the morning star. Let anyone who has an ear listen to what the Spirit is saying to the churches.* —REVELATION 2:18–29

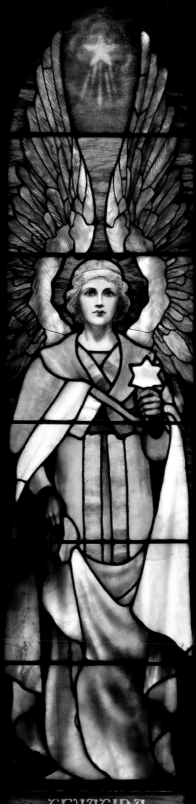

THYATIRA

He that overcometh, will
I give power over the na-
tions — and I will give
him the morning star.
Rev 11:26 & 28

**PHYSICAL DESCRIPTION**

The angel of Thyatira, an androgynous figure who faces the viewer and stares out of the window with a direct gaze, holds in his left hand a six-pointed glowing star, a vivid counterpoint to the less luminous five-pointed star that shines out from the top of each of these windows. His dress is vaguely priest-like, a robe with a cape and front ribbons that resemble an ecclesiastical chasuble. In his right hand, he holds the drapery of his robe.

**GEOGRAPHICAL SETTING**

Today the city of Thyatira is called Akhisar, located between Pergamum and Ephesus, approximately thirty-five miles inland. Thyatira was originally a Macedonian military settlement, a bulwark against the armies to the east. It was no longer a garrison town at the time of the writing of Revelation, but was a wealthy industrial center, the home of numerous guilds. The prophecy to this church comes from the "Son of God, who has eyes like a flame of fire, and whose feet are like burnished bronze" (2:18), and biblical scholars have suggested that the references to fire and bronze are direct allusions to the metal-working guilds of this city.[1] Indeed, the guilds seem to be at the heart of this letter.

According to William Ramsay, there were "more trade guilds known in Thyatira than

Arcade in Thyatira. Originally a Macedonian military settlement, Thyatira served as a barrier against eastern armies. Soon the city turned to commerce, containing more trade guilds than any other Asian city at the time.

any other Asian city: wool workers, linen workers, makers of outer garments, dryers, leather workers, tanners, potters, bakers, slave dealers, and bronzesmiths."[2] In order to conduct business, members of each of the guilds would have to offer sacrifice to the patron god, Apollo Tyrimnaeus; Colin Hemer sees the guilds as, in essence, religious institutions and also remarks on the variety of races that had settled in the city.[3] This led to the danger of compromise or reconciliation with pagan rituals that has been remarked on in relation to the other cities.

The "Jezebel" of the Thyatiran letter has long posed a problem for scholars, who have tried to identify her or to pinpoint her prominence in the community, but she was surely a person of influence in Thyatira and connected in some way with the dangerous syncretizing tendency to accept pagan rituals, particularly offerings to the gods, as simply being part of business in Thyatira.

*Apollo Belvedere,* marble, Roman copy (c.135 CE) of a Greek bronze original (c. 325 BCE), Museo Pio-Clementino, Vatican Museums. Apollo Tyrimnaeus was the patron god of Thyatira. In order to conduct business, members of each of the city's many trade guilds were required to offer sacrifices to Apollo.

## BIBLICAL MEANING

One of the least important and smallest of the seven cities of Revelation, Thyatira, receives the longest epistle from John and also the greatest praise: "I know your works—your love, faith, service, and patient endurance. I know that your last works are greater than the first" (Rev. 2:19). Those who maintain this faith and service are promised what appear to be earthly rewards: "I will give authority over the nations; to rule them with an iron rod, as when clay pots are shattered—even as I also received authority from my Father" (Rev. 2:26–28). This is remarkable power: to receive authority over nations as supreme as the power of the Son of God. But there is a catch: the church of Thyatira has tolerated "that woman Jezebel," a fornicator and

compromiser. This strange woman and her followers will soon be thrown into "great distress," and her children will be struck dead.

SPIRITUAL SENSE Swedenborg sees this intriguing letter in quite a different fashion. None of the historical facts about the city is important; rather, as with the other cities, he bases his interpretation on the inner meaning of the words that are used.

*Jezebel* by John Liston Byam Shaw, 19th century, Russell-Cote Art Gallery and Museum, Bournemouth, England. The "Jezebel" of Thyatira was most likely a person of influence in the city, connected with the dangerous syncretizing tendency to accept pagan rituals such as offering sacrifices to the gods.

The first three churches represent people who believe that they will be saved by a strict belief in doctrine (Ephesus), people who believe that only love is needed for a good life (Smyrna), and people who believe that actions speak louder than words and mean more than the rules of conduct (Pergamos). The first three have only a part of the full equation; however, the morning star held by the angel of Thyatira suggests that the church of the same name represents a union of love and wisdom in action, a perfect blend (see below). The church of Thyatira also has a second association—those who separate faith from charity and are, thus, in a spiritual state of evil.

The person on earth is in a state of regeneration—that is, he or she is working to improve and grow spiritually—and therefore is subject to various temptations. No one is completely regenerated until after death, when he or she has stripped away all the natural, lower understanding that was acquired on earth and has accepted spiritual truth. The person represented by Thyatira is on an even keel, but he or she, being human and subject to the pulls of the materially oriented mind, is certainly capable of losing that balance and going overboard. One great temptation in this life is the idea that faith alone can save a person, as opposed to faith that is

combined with good works. This is represented by "Jezebel," whom Swedenborg sees as representing the spiritual principle of faith separated from charity (*Revelation Unveiled* §132).

What does this mean exactly? William Bruce has interpreted Jezebel as "the symbol of some destructive principle which seeks admission into the human mind and, when admitted, strives to turn it, by its delusive insinuations, from the true worship of the Lord."[4] She is especially troublesome because she is a "prophet," someone who speaks and persuades with divine authority. So, this temptation—to leave the balanced life of charity and truth and to live a life of faith alone, devoid of good works and love—can work its way into the balanced person's mind under a guise of truth.

For Swedenborg, people who believe in salvation by faith alone have an outer life of piety, reverence, and duty, yet at heart lack the inner truths of the religion. In this world, there is no way to see into a person's heart; dissimulation is easily accomplished by words and deeds. But the Lord is "the one who searches minds and hearts" and "will give to each of you as your works deserve" (Rev. 2:23). He can see into our innermost hearts and discern what our thoughts and intentions are.

It may seem odd that Jezebel deserves a "bed," the symbol of her fornication. Swedenborg,

*A bed means the theology that each of us adopts, whether we get it from the Word or from our own intellect, because it is where our mind is at rest and, so to speak, sleeps.*

*This and nothing else is the source of the beds on which people rest in the spiritual world. Each of us there has a bed that matches the quality of our knowledge and intelligence—splendid for the wise, shoddy for the unwise, and filthy for deceivers.* —REVELATION UNVEILED §137

however, sees the bed as fitting as it reflects Jezebel's inner falsehood. The false doctrine of salvation through faith alone is filthy, according to Swedenborg, and sullies and defiles the marriage of love and truth.

So insidious is the doctrine of faith alone that in his discussion of the letter to Thyatira Swedenborg includes a story based on his own visionary experiences (*Revelation Unveiled* §153). It seems that people who believe in this doctrine while still on earth are so hard-headed that once they have died, even after heavenly instruction by angels and seeing truth in the life of heaven, they are incapable of reform. After explaining to the reader how the spirits of the dead "awaken" in the afterlife and are introduced to the various heavenly and hellish societies so that each spirit will find his or her home, Swedenborg reveals the fate of those who are the most troublesome spirits:

> It is different, though, for people who have convinced themselves, by both their theology and their life, that faith alone is fully adequate for justification. Since they are responsive to what is false and not to what is true and since they have excluded from the means to salvation the good effects of caring, which are good works, they are led away from good communities and into evil ones. They too are brought to various different ones until they arrive at a community that answers to the compulsions of their love; since if we love what is false, we inevitably love what is evil. (*Revelation Unveiled* §153)

These deluded spirits, as part of their afterlife vocation, are given various offices of administration in societies in the World of Spirits, the spiritual realm located between heaven and hell. However, they always lose their jobs because

they cannot learn truth—they cling to their old ways. Their spiritual adventure continues, but it is a lonely journey of solitude and rejection, sadness and dejection. Eventually, after many failures in various societies and in various positions, each one lowlier than the preceding, yet each one calling for more stamina and endurance than these spirits can muster, the crazed spirit comes to a cave, inside of which is a workhouse. Here these spirits live forever in company with likeminded individuals. As long as they meet the demands of their overseer, they are fed and clothed and suffer no harmful effects. In this hellish afterlife, they are fit for only the most menial labor, although once many had been considered persons of merit and rank.

*Cave at Evening,* 1774 by Joseph Wright of Derby (1734–97), oil on canvas, Smith College Museum of Art, Northampton, Massachusetts. Swedenborg explains that each spirit finds his or her home in the afterlife. People that believed they would be saved by faith alone eventually come to work in a cave, fit for only the most menial labor.

On the other hand, if the Thyatiran holds fast to the love and truth she knows to be the highest degree of spiritual awakening and doesn't fall prey to the dissimulations of false doctrine, then she will rule nations. Surely, this cannot be a literal reward; rule and domination over others are signs of hell: "All people [in hell] want to control others and be preeminent," Swedenborg writes. "They hate the people who do not agree with them, and use vicious means to get even with them because this is what selfishness is like. So for them it is the more vicious ones who hold office, and who are obeyed out of fear" (*Heaven and Hell* §220).

Swedenborg sees the "nations" that the faithful Thyatiran will rule as a reference to both good and evil in an abstract sense. Thus, ruling over nations signifies that the person will have the power to overcome evils within her own nature. There will no longer be a struggle with temptation; she will rule herself with "an iron rod," a symbol of power and revealed truth. Along with this symbol of personal power, the

*David with the Head of Goliath,* 1620 by Domenico Fetti (1588–1623), Royal Collection, London. Thyatira is promised that she will "rule nations" if she holds fast to love and wisdom. Swedenborg interprets this as the person will have power to overcome evils within herself, no longer struggling with temptation. David overcame Goliath with his personal power supported by his trust in God's wisdom.

Thyatiran who is true to the first and last will receive the morning star.

Stars to Swedenborg represent the knowledge of truth and good. "When angels are below heaven, they seem to be surrounded by a host of little stars. The same is true of spirits who had experienced discoveries of what is good and true, or who had gathered from the Word truths for their lives and for their understanding of theology while they lived in this world" (*Revelation Unveiled* §51). And "morning" has several degrees of meaning in Swedenborg's works, but perhaps it is best described in *Heaven and Hell* §155: "Morning [represents] the first and highest level of love." The morning star is the conjunction of love and wisdom. Again, the balance is achieved.

Framed by red wings and red lining of the cloak, both representing love, the angel of Thyatira holds the star of truth to lead people to do good works as an expression of their faith and not be swayed by the temptations of faith alone. The angel of Thyatira, in his priestly robes, stands straight and looks forthrightly out at the viewer. Holding in his hand the symbol of unity, he is emblematic of the strength derived from conquering the self and triumphing over earthly temptations and falsehoods.

ANGELIC WISDOM   The angel of Thyatira represents a spiritual state and a people who are at a crossroads. How can one do good works and live in faith and yet be subject to the pitfall of faith alone? Perhaps this is a reminder that no matter where we are on the spiritual path, as long as we are in the natural world, we will be subjected to the temptations

*Bethsabée,* c.1890 by Jean-Léon Gérôme (1824–1904), private collection. Bathsheba was married to the soldier Uriah the Hittite. King David saw her bathing, and immediately gave into temptation and soon she was pregnant with his child. In order to hide his sin, David had Uriah killed in battle and took Bathsheba as his wife. Their first child died as punishment for David's sin. Temptations are false prophecies and ideas that adulterate the divine essence of spiritual life.

of false prophecy and ideas that adulterate the divine essence of spiritual life.

Since only God can see our intentions and read our hearts and minds, we cannot judge another by the faith professed and conclude that this person is whole and complete. To hold onto only a part of the truth and dismiss the rest puts one in a precarious position, like a stool without all of its legs. This state will subject a person to evil influences without the necessary strength and clarity to withstand temptation. Since separating faith from charity is an adulteration of spiritual life, it is important to stay open to divine guidance from the truths of faith and the love of good and thereby avoid the parched state of faith alone. ✤

*Morning,* 1808 by Phillipp Otto Runge (1777–1810), oil on canvas, The Hamberger Kunsthalle. The morning star is the combination and balance of love and wisdom, representing the highest level of love.

*Lord, give me the strength to resist temptations
that pull me from my path.
Let my road go straight to you
as I allow the shining star of truth to lead me.
Shine your light on false ideas
that are separated from your love,
and allow my expression and works
to manifest your love for all people.
Amen*

**PRAYER**

# The Angel of Sardis

HE THAT OVERCOMETH,
THE SAME SHALL BE CLOTHED IN WHITE
AND I WILL NOT BLOT OUT HIS NAME
OUT OF THE BOOK OF LIFE

*And to the angel of the church in Sardis write: These are the words of him who has the seven spirits of God and the seven stars:*

*I know your works; you have a name of being alive, but you are dead. Wake up, and strengthen what remains and is on the point of death, for I have not found your works perfect in the sight of my God. Remember then what you received and heard; obey it, and repent. If you do not wake up, I will come like a thief, and you will not know at what hour I will come for you. Yet you have still a few persons in Sardis who have not soiled their clothes; they will walk with me, dressed in white, for they are worthy. If you conquer, you will be clothed like them in white robes, and I will not blot your name out of the book of life; I will confess your name before my Father and before his angels. Let anyone who has an ear listen to what the Spirit is saying to the churches* —REVELATION 3:1–6

**PHYSICAL DESCRIPTION** A beautiful figure, wearing shining white armor encrusted with golden stones around his neck and swathed in a white robe, the angel of Sardis holds the book of life, the very tome from which the names of the unrepentant of Sardis will be obliterated. Drapery glass subtly changes from yellow to green to blue in the folds of the robe. The tunic beneath the armor is trimmed with yellow ripple glass, and the book of life, held in the angel's right hand, is depicted in mottled glass to simulate a leather binding.

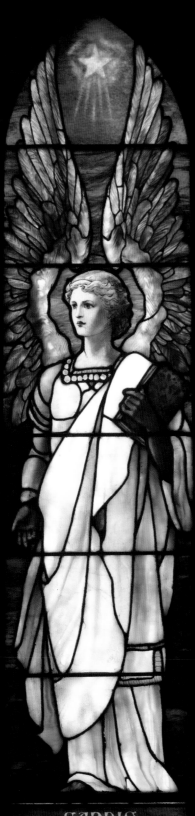

SARDIS

He that overcometh, the same
shall be clothed in white; and
I will not blot out his name
out of the book of life.
Rev. III. 5.

*Alexander the Great*
(mosaic). Sardis was con-
quered by the armies
of Alexander the Great in
334 BCE, and the city fell
under Greek control.

At the height of its power in the sixth century
BCE, Sardis was the capital of the kingdom of
Lydia, ruled by King Croesus, who was fabled
for his wealth. However, he lost the city, along
with the rest of his empire, in a war with the
Persians. Sardis fell under Greek control when
it was conquered by the armies of Alexander
the Great in 334 BCE and was absorbed into the
Roman Empire in the second century BCE.

Sardis had a thriving Jewish community at
the turn of the first century and, indeed, seems
to have had a sizable Jewish population over a
period of many centuries, even when the city
was under Greek control. It has been suggested
that the majority of Christians in Sardis had
come to terms with the Jewish elements in the
city and were enrolled in the synagogues. To
have one's names erased from a synagogue roll
or a list of citizens could have had dire conse-
quences in the first century CE,[1] but the letter
threatens an even more bitter fate—having one's
name removed from the heavenly book of life.

In the letter to the Sardinians, the author
states bluntly that "you are dead"(Rev. 3:1).
Indeed, to biblical scholars, Sardis represents
a dead city. Though Sardis was built on a
promontory and appeared to be an unassailable
stronghold, it was actually built on mudrock,
which, as W. R. Ramsay describes it, is

Ruins of the Sardis
synagogue courtyard.
Sardis had a thriving
Jewish community, and
it is possible that many
of its Christian citizens
attended synagogue.

"easily dissolved by rain." In addition, Sardis was devastated by an earthquake in 17 CE, adding to its reputation for "instability, untrustworthiness, inefficiency, and deterioration."[2] Ramsay goes further: "It was a city whose history conspicuously and pre-eminently blazoned forth the uncertainty of human fortunes, the weakness of human strength and the shortness of the step which separates over-confident might from sudden and irreparable disaster. It was a city whose name was almost synonymous with pretensions unjustified, promise unfulfilled, appearance without reality, confidence which heralded ruin."[3] In effect, it was a crumbling city, the ground under it eroding away bit by bit, until the cliff on which it was built would fall into the sea.

To other scholars, the presence of Asiatic pagan cults, particularly the worship of the city's tutelary goddess Cybele, is more significant. There was also a sizeable segment of Roman emperor worship. After the earthquake of 17 CE, Tiberius had sent money for rebuilding the city, so its citizens were particularly indebted to the empire.

*Bust of Cybele,* first century CE, Gallo-Roman bronze, Cabinet des Médailles, Bibliothèque nationale de France, Paris. The Phrygian earth goddess represents fertility, caverns, mountains, wild animals, and walls and fortresses. The Greeks referred to her as "Mountain-Mother."

**BIBLICAL MEANING**

The epistle to the church of Sardis is the shortest of the apocalyptic epistles, the most direct and harsh in its admonishments. Despite the city's failure to thrive in its faith, there are still a few Sardinians who remain upright and righteous: to these (as to those who repent) is promised union with the Lord ("they will walk with me") and a robe of white.

**SPIRITUAL SENSE**

Swedenborg's interpretation of this short epistle is among the most interesting. The person represented by Sardis is one who follows forms—the

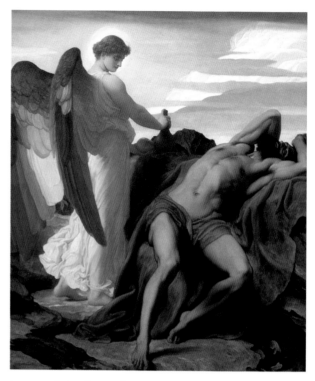

*Elijah in the Wilderness* by Frederick Leighton. In the letter, Sardis is commanded twice to wake up. Spiritual sleep is an obscure, befuddled state, as if one were walking in a fog or smoke. Wakefulness is a state of spiritual clarity, in which the light of spiritual truth is let into the heart and mind.

letter of the law—but gives no thought and has no desire to learn the spirit, the interior truth. Such a person is a church member; he says the necessary prayers, attends the prescribed services, even believes himself to be a good man. Yet he is completely lacking in any inner fire. He is admonished twice in this epistle to wake up, to be alert and watchful. Swedenborg analyzes this command as a call to seek after and learn truth and then live by it. Spiritual sleep is an obscure, befuddled state, as if one were walking in fog or smoke. Wakefulness is a state of spiritual clarity, in which the light of spiritual truth is let into the heart and mind and in which the person gratefully accepts and acknowledges that this is the grace of God. Indeed, these prophetic words come from him who "has the seven spirits of God and the seven stars": in Swedenborg's interpretation, the seven spirits are "the life of Divine truth which is infused into the mind of the regenerate man by an interior way,"[4] while the seven stars are the knowledge a person on a regenerate path (one of spiritual growth) receives from contemplating the Bible. Sardis represents

those who live an outwardly good life and so
receive approbation from others but who are
inwardly in darkness and confusion, lacking the
light of truth and any interest in seeking the
true meaning of the Word. Swedenborg relates a
story about such a person in the afterlife:

> I have also had occasion to hear a great
> many people in the spiritual world saying
> that they had often taken Holy Commu-
> nion, which meant that they had eaten
> and drunk what was holy; that every time
> they had been absolved of their sins; that
> every Sabbath they had been attentive
> to their teachers and that they had faith-
> fully said their prayers at home morn-
> ing and evening; and so on. When what
> was within their worship was let out,
> though, it turned out to be full of iniq-
> uity, and hellish, so they were rejected.
> When they asked where all this came
> from, the response was that they had not
> had the slightest interest in divine truths.
> (*Revelation Unveiled* §157)

Spirits spend as long as is necessary in the
World of Spirits, the intermediate realm between
heaven and hell. There, bit by bit, they learn
their true nature and also learn the truth about
spiritual reality. Some spirits, however, aren't
good candidates for reeducation, because on

*The Nightmare,* 1781 by
Johann Heinrich Füssli
(1741–1825), oil on canvas,
Institute of Fine Arts,
Detroit.

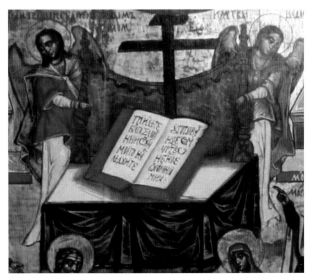

*Book of Life from The Last Judgment.* Icon, Russian, probably 18th century. Swedenborg writes that all people are created to go to heaven, so the spiritual book of life is a registry of all people who have been born. Only those who reject love and wisdom will have their names blotted from the registry.

earth, they were utterly committed to their own point of view. Among these are people who are truly stuck in dead worship. The spirits described above go on to question the angels: "Who needs truths? What are truths?" At this point, they are no longer able to receive truth and so are left to their own devices.

While spirits of good will, receptive heart, and open mind are able to learn after death, regeneration is best accomplished on earth. Those Sardinians who have been open to truth or who are able to correct the errors of their ways while alive will be clothed in white and walk with the Lord. Garments as external coverings represent the inner being in Swedenborg's theory of correspondences. Thus, in *Heaven and Hell,* we learn that the garments that angels wear reflect their inner being, so that the most intelligent angels "have clothes that gleam as though aflame, some radiant as though alight. The less intelligent wear pure white and soft white clothes that do not shine, and those still less intelligent wear clothes of various colors. The angels of the inmost heaven, though, are naked" (*Heaven and Hell* §178). Likewise, the clothes of those in hell are "nothing but rags, dirty and foul, each individual in keeping with his or her own insanity"—in spiritual terms, their lack of

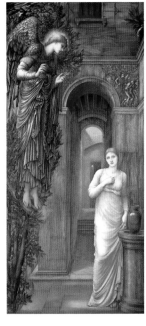

*The Annunciation,* c. 1876 by Edward Burne-Jones (1833–98), oil on canvas, Lady Lever Art Gallery, Merseyside, United Kingdom.

love and truth (*Heaven and Hell* §182). To walk
in white robes, then, indicates that the regener-
ate person has led an inner life that holds truths
in a purified state. The angel of Sardis is not one
of those who perform empty rituals and live by
rule and rote; rather, he is a living symbol of
unsullied truth.

Swedenborg asserted in *Heaven and Hell*
(§311) that heaven and hell are derived from
the human race. All people are created to go to
heaven; by our thoughts and actions on earth,
we are consciously choosing whether we accept
that design. So the spiritual book of life is a
registry, as it were, of all people who have been
born. Only those who reject love and wisdom
will have their names blotted from the registry.
However, those who remain on the rolls of
heavenly citizens are not all equal. Everyone
in heaven is an angel, but some angels, as
we have seen, are better situated than others,
according to their conjunction with divine
love and wisdom.

*I have also been allowed
to see an angel of the cen-
tral heaven. His face was
more glorious, more radi-
ant, than that of angels
of the lower heavens. I
looked at him very closely,
and he had a human
form in full perfection.*
—Heaven and Hell §75

Swedenborg describes three heavens: the
innermost or celestial, constituting the bright-
est angels, the purest of heart and most recep-
tive to divine love and wisdom; the middle or
spiritual, encompassing the angels who did not
immediately and automatically receive truth
but accepted it intellectually and lived a good
life; and the outermost or natural.[5] In this last
heaven live angels who led a moral life in accor-
dance with their precepts and accepted God, but
cared nothing about or never received the truth.

What does this have to do with having one's
name confessed before the Father and his angels?
The "Father" to Swedenborg represents the part
of the Lord that is Divine Love, while the "Son,"
the part that is Divine Wisdom. To "confess the
name of any one before His Father is to bring

that soul into conformity with and into posses-
sion of His Love."[6]

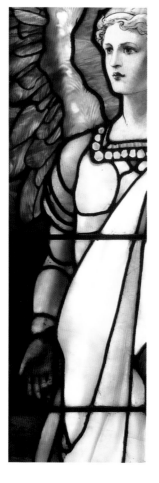

The brightness of the Sardis angel comes from
the preponderance of the color white, which
is universally held as representing purity and
cleanliness. In his commentary on this epistle,
Swedenborg notes that white represents truth,
and that being clothed in white signifies that
the wearer has received truth directly from the
Lord, and therefore is able to walk with him
(*Revelation Unveiled* §167).

Tiffany's angel of Sardis represents the
triumph of spiritual intelligence, an illumina-
tion from the Lord. His robes glow with an
inner light that is accomplished by the artist's
use of drapery glass, which creates a lumines-
cent reflection of green, blue, and yellow in the
inner gown. These colors signify, in Sweden-
borg's system, the principles of science, the truth
of heaven, and the color of good, respectively.
Taken together, the three colors indicate the
natural, spiritual, and celestial levels of heaven
and of a person's inner being.

In his left hand, the angel holds the glowing
book of life, an ancient symbol of one's place
in the Heavenly City. Those who persevere in
truth will have their names inscribed in the rolls

*Christ Glorified in the Court
of Heaven,* 1428–30 by
Fra Angelico (1387–1455),
tempera on wood, National
Gallery, London. Those
who persevere in truth will
have their names inscribed
in the rolls of the citizens
of the Heavenly City,
and their names will be
announced before God
and the angels.

of the citizens of heaven, indeed, have their names announced before God and the angels. Despite the outward harshness of the epistle to Sardis, the bright angel and the glowing book promise a reward to those who grow spiritually through truth.

The spiritual state represented by the church of Sardis is death—a spiritual death rather than a merely physical one. The worship of the people of Sardis is empty and not based on love or truth. Outwardly they appear to be good, but this is a sham. When a person goes through the motions of worship for the sake of appearance rather than as an expression of love, there is no good to these actions, only hypocrisy. The key is to bring life, which is love and wisdom, into worship; otherwise, it is merely a façade, not based on true connection with the divine.

To overcome the Sardis state, we must examine ourselves to see where our actions and worship are rooted. If we find no connection between our outward expression and inward state, then it is time to reform ourselves, to seek a higher wisdom so that we can become more spiritual beings. This is a state of waking up to life, rather than being asleep. By seeking higher wisdom and connecting ourselves to it, we enliven our worship and spiritual practice. ✦

*The Vision of the Last Judgment* (1808) by William Blake. If we find no connection between our outward expression and inward state, then it is time to reform ourselves, to seek a higher wisdom so that we can become more spiritual beings. This is a state of waking up to life, rather than being asleep.

*Lord, help me to examine myself
and seek to connect with your truth
so that my words and actions are sincere.
In this way, I can wake up to life
so that all that I do and say
are rooted in your wisdom.
Amen*

**PRAYER**

# The Angel of Philadelphia

HIM THAT OVERCOMETH
WILL I MAKE A PILLAR
IN THE TEMPLE OF MY GOD
—AND I WILL WRITE UPON HIM
MY NEW NAME.

And to the angel of the church in Philadelphia write:
These are the words of the holy one, the true one
who has the key of David
who opens and no one will shut
who shuts and no one opens:
I know your works. Look, I have set before you an
open door, which no one is able to shut. I know that
you have but little power, and yet you have kept my
word and have not denied my name. I will make those
of the synagogue of Satan who say that they are Jews
and are not, but are lying—I will make them come
and bow down before your feet, and they will learn
that I have loved you. Because you have kept my word
of patient endurance, I will keep you from the hour
of trial that is coming on the whole world to test the
inhabitants of the earth. I am coming soon; hold fast
to what you have, so that no one may seize your crown.
If you conquer, I will make you a pillar in the temple
of my God; you will never go out of it. I will write on
you the name of my God, and the name of the city of
my God, the new Jerusalem that comes down from my
God out of heaven, and my own new name. Let anyone
who has an ear listen to what the Spirit is saying to the
churches. —REVELATION 3:7–13

**PHYSICAL DESCRIPTION** This is the darkest of the seven windows in the series. In contrast to the glowing white of the angel of Sardis, only the upper body of the angel of Philadelphia shines in its golden armor, which is encrusted at the neck with yellow and white jewels. The youthful figure's left arm rests on a pillar of opalescent glass, the symbol of the

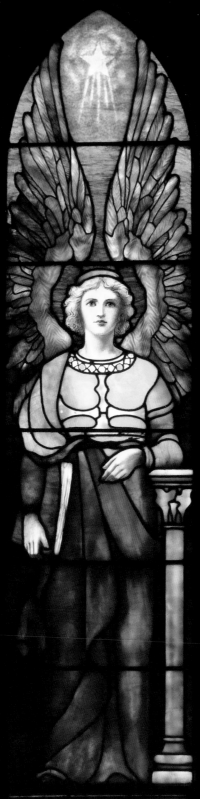

PHILADELPHIA

Him that overcometh will
I make a pillar in the temple
of my God — and I will write
upon him my new name.

promise to these faithful servants. In his right hand, he clasps a book, perhaps another version of the book of life. The rest of the window is shadowed in darkening shades of browns, blues, and greens.

This is a somewhat somber window for such a laudatory epistle. The church of Philadelphia receives the highest praise of the seven cities. It may be the least significant of the cities in power, but it is the grandest in the sight of God. The church has remained steadfast and true against those who would attack it, and it will be protected from the horrors of the coming apocalypse.

## GEOGRAPHICAL SETTING

Of the seven cities, Philadelphia was the last to be founded; it was established in 189 BCE by King Eumenes II (197–160 BCE) of the kingdom of Pergamon. The city was named in honor of the king's brother and successor, Attalus II (159–138 BCE), who earned the nickname "Philadelphus," signifying "brotherly love," for his loyalty. The city came under Roman control in 133 BCE when the last of its kings, Attalus III Philometer, died without an heir and bequeathed his lands to the Romans.

According to W. M. Ramsay, Philadelphia's importance was as "missionary city"; its purpose was to spread Greek influence into Lydia and Phrygia.[1] But the popular conception of the city was of its structural faults, related to the earthquake of 17 CE, which also devastated Sardis. So bad was the damage at Philadelphia that its tribute to Rome was remitted for five years, and it, like Sardis, received Rome's beneficence in rebuilding. Philadelphia was at the epicenter of the earthquake and was continually rocked by aftershocks for years after. Because of the

instability of the city, very few people actually lived within the city walls; most of the city's inhabitants lived in the open plains around the city, where no structures could collapse on them in the event of another disaster.[2] Yet this city, noted in popular thought as unsafe and unstable, is praised in the epistle as the soundest and most steadfast in faith, rock-solid in endurance and strength in tribulation.

In addition, scholars comment on Philadelphia's close relationship to Rome and to the cult of the emperor. In thanks to Tiberius for his continued generosity after the earthquake, the city founded the cult of Germanicus, Tiberius's brother.[3] But the benevolence of the Roman emperors could be fickle. Colin J. Hemer discusses a decree by Domitian in 92 CE that half the vineyards in the Asian provinces had to be cut down; this had a profound impact on all of Rome's Asian provinces but particularly Philadelphia, which, along with earthquakes, was well known for its fertile soil and agricultural production.[4]

*Autumn* from the Tacuinum Sanitatis f54v, c. 1390, Austrian National Library. Philadelphia was known for its fertile soil and agricultural production. In 92 CE the emperor Domitian decreed that half of the vineyards in the Asian provinces had to be cut down.

Biblical scholars, then, see the various images and phrases in the letter to the Philadelphians as references to political events of that time period. In contrast to the vagaries of the earthly emperors, God will protect the faithful in Philadelphia in the hour of devastation. They will no longer live in fields but will themselves be a pillar in an indestructible temple, and "you will never go out of it" (Rev. 3:12). Instead of their livelihood being taken away from them, they should "hold fast to what you have, so that no one may seize your crown" (Rev. 3:11). And, of course, the epistle also makes a direct reference to religious matters: the "synagogue of

**BIBLICAL MEANING**

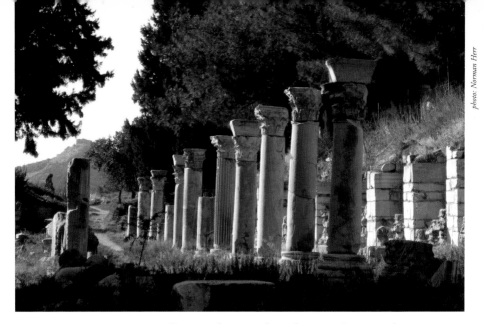

Colonnade in commercial agora. Because of the unpredictable earthquakes that so often rocked the city, many Philadelphians lived outside the city walls, where no structures could collapse on them. Despite its physical instability, Philadelphia is praised as the most sound and steadfast in faith, most solid in endurance and strongest in tribulation. God will protect the Philadelphians, and they will no longer live in fields but will themselves be a pillar in an indestructible temple.

Satan who say that they are Jews and are not, but are lying" (Rev. 3:9).

This last phrase echoes the same warning to Smyrna: "I know the slander on the part of those who say that they are Jews and are not, but are a synagogue of Satan" (Rev. 2:9). While Hemer asserts that there is no external evidence for a Jewish congregation in Philadelphia at this time, he also states that "a few years later Ignatius had to combat a Judaizing schism in the church there."[5] We have seen in other letters that the rolls of a synagogue were important in these seven cities: although the Christians were not practicing Jews, many of them were still enrolled in a synagogue. Why? Because Christianity was a proscribed religion in the empire, while Judaism was not. According to *The International Standard Bible Encyclopaedia*: "At first the Christians were not distinguished from the Jews, but shared in the toleration, or even protection, which was usually conceded to Judaism as the national religion of one of the peoples embraced within the empire. Christianity was not legally proscribed until after its distinction from Judaism was clearly perceived" (4:2622).

While it is not known precisely when edicts outlawing Christianity were proclaimed, scholars know that Christianity had not been outlawed

at the time of the great fire in Rome (64 CE) but was by 112 CE, during the reign of Trajan; they generally believe that an official act was put in place sometime at the end of Nero's reign in 68 CE. It is also accepted that Domitian (80–96 CE) persecuted Christians (this is around the time usually assigned to the writing of the book of Revelation). So, it was important that Christians "be on the books," as it were, of an accepted religion, one that "offered every Jew implicitly a licence to practise his religion and an exception from the requirement of the imperial cult on condition of payment [of a temple tax] and the implied recognition of the Roman national deity."[6] This may have been seen by some of the more ardent in the Christian community as an act of compromise, even though it was necessary for safety's sake. Refusal to offer sacrifices to the Roman gods and the living emperor before their statues was considered proof of being a traitor to the state.[7]

*Head of Nero,* c. 64 CE, from an oversized statue, Glyptothek, Munich. It is believed that Nero officially outlawed Christianity around the end of his reign in 68 CE. Christians were popularly blamed for the great fire in Rome in 64 CE, though contemporary historians Suetonius and Cassius Dio write of Nero as the arsonist, claiming that he started the blaze in order to clear space for a new palatial complex the Domus Aurea, which he built between 64–68 CE.

## SPIRITUAL SENSE

Swedenborg, as we have seen, was not concerned with the historical evidence (although he believed that one level of the Bible was historical) but with the hidden, interior meaning of the words and symbols. Philadelphia is clearly to him a blessed place, a church where truth that is recognized as coming from the Lord is accepted and cherished. This is underscored by the speaker, who identifies himself as "the holy one, the true one": the Lord as divine truth (*Revelation Unveiled* §173). The person represented by Philadelphia accepts that truth comes not from human intellectual acumen but from an inflowing of wisdom from God. The Lord's protection is extended through the open door; he alone can open and shut the door to

*Descent into Hell and Salvation of Adam* from the fresco series in the Dominican convent of San Marco (c. 1437), Museo di San Marco, Florence, Italy. While not explicitly referred to in Scripture, the "Harrowing of Hell" refers to Christ's journey into hell before the Resurrection, rescuing the souls of the righteous dead, particularly Adam and Eve. Swedenborg writes that the temptations of hell are powerless to attack anyone to whom the door of salvation is opened.

salvation, and the temptations of hell are powerless to batter it down or successfully to attack anyone to whom the door is opened.

The Philadelphian has "little power" not because she is insignificant or dominated by others but because, in a state of regeneration (or spiritual growth), she recognizes that power does not come from her own personal strength; it comes from alignment with God. We have free will to choose our actions: accept the Lord's light or turn toward the darkness of evil. And if we choose to accept the light, then we acknowledge the source of that light and its influence on our lives.

Likewise, the "synagogue of Satan who say they are Jews and are not" has a deeper meaning. In his discussion of the epistle to the church of Smyrna, where there was a similar phrase, Swedenborg interprets the term "Jews" as

referring to people who act out of love for good-
ness; therefore, those who falsely claim to be Jews
are people who seem to be acting out of love but
are not. These people are pretenders who per-
form the outward acts of religion for the sake of
propriety, not from any inner belief. To everyone
else, such a person appears to be conscientious
and dutiful, yet in reality he has chosen the dark-
ness, reflected in his spirit, which, of course, can-
not be seen while on earth. The true "Jews" are
the Philadelphians—those who allow God's truth
into their hearts. They will eventually conquer
and be admitted through the open door, while
the hypocrites will be denied admission.

The final promise to the faithful Philadel-
phian may seem obscure: "I will write on you
the name of my God, and the name of the city
of my God, the new Jerusalem that comes down
from my God out of heaven, and my own new
name." In Swedenborg's system of correspon-
dences, the name of God signifies divine truth;
therefore writing the name of God means that
the truth is inscribed on one's heart. "The city of

*When the Lord was in the
world he made his human
nature conform absolutely
to divine truth, which
is also the Word; and
when he departed from
the world he fully united
that divine-true nature
to the divine-good nature
that was within him from
conception. In fact, the
Lord glorified his human
nature—that is, made it
divine—in the same way
that he makes us spiritual.
He first instills truths from
the Word into us and then
unites them to what is
good; and it is through
this union that we become
spiritual.*—REVELATION
UNVEILED §193

*Open Door on a Garden*
by Konstantin Somov
(1869–1939), oil on canvas.
The Lord's protection
is extended through the
open door; he alone can
open and shut the door to
salvation, and the tempta-
tions of hell are powerless
to batter it down or attack
anyone to whom the door
is opened.

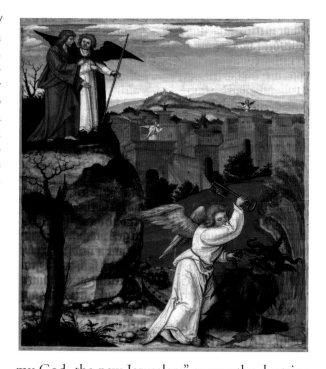

*The Heavenly Jerusalem/ The Bound Devil* from the Ottheinrich Bible (c. 1530) by Matthais Gerung (1500–70). The New Jerusalem does not refer to any earthly church, but a new spiritual age in which humanity will be able to deeply experience God's love and wisdom.

my God, the new Jerusalem" means the doctrine of the new church—not any one earthly church but a new spiritual age in which humanity will be able to more truly and deeply experience God's love and wisdom. "My own new name" refers to worship of God alone, without allowing ourselves to be distracted by the temptations of the world around us, no matter what good things they seem to bring. This final promise, then, is that the faithful will receive divine truth and will become a reflection of the New Jerusalem, the new church that exists both in heaven and on earth.

SPIRITUAL MEANING OF THE DETAILS

The somber coverings of the angel of Philadelphia obscure the golden, jewel-encrusted armor that is his power. He has no need to be ostentatious or display his greatness; his truth and power are written on his heart. His strength is represented by the solid pillar, indicating that he upholds truth, and the mysterious, unobtrusive closed book, the book of life.

The people of Philadelphia represent the spiritual state exemplified by this angel, which is one of humble endurance and a life based on truth from God. People in this state have access to the wisdom that allows them to always see life from a loving perspective; however, they must continue to have the patience to do what is right, knowing that the rewards of eternal salvation will be theirs. For people on a path of spiritual growth, this message reinforces the need to have faith and trust that all will be well.

It is easy to lose concentration or stray from what we know is right, but the words written to this angel remind us to continue on the right path, as pillars of strength, and to remember that we must constantly be mindful of our actions and not lose patience. This spiritual state acknowledges that all power comes from a higher source, and it brings the greatest reward of all—wisdom that comes from sincere humility. ✣

*Lord, give me the strength*
*to remember the source of all good,*
*and to be open to the loving wisdom*
*that comes from you.*
*In this way, I can stay*
*on the path of the good and true*
*and spend my eternal life in heaven.*
*The door is open, and none can shut it*
*if I continue to do your will.*
*Amen.*

# The Angel of Laodicea

To him that overcometh
will I grant to sit with me
in my throne

*And to the angel of the church in Laodicea write: The
words of the Amen, the faithful and true witness, the
origin of God's creation:*
*I know your works; you are neither cold nor hot. I
wish that you were either cold or hot. So, because you
are lukewarm, and neither cold nor hot, I am about
to spit you out of my mouth. For you say, "I am rich, I
have prospered, and I need nothing." You do not realize
that you are wretched, pitiable, poor, blind, and naked.
Therefore I counsel you to buy from me gold refined by
fire so that you may be rich; and white robes to clothe
you and keep the shame of your nakedness from being
seen; and salve to anoint your eyes so that you may see.
I reprove and discipline those whom I love. Be earnest,
therefore, and repent. Listen! I am standing at the door,
knocking; if you hear my voice and open the door, I will
come in to you and eat with you, and you with me. To
the one who conquers I will give a place with me on my
throne, just as I myself conquered and sat down with
my Father on his throne. Let anyone who has an ear
listen to what the Spirit is saying to the churches.*
—REVELATION 3:14–22

**PHYSICAL
DESCRIPTION** The angel of Laodicea appears as a conquer-
ing warrior, wearing a gold crown on his head
and holding a scepter in his left hand. He wears
armor, Christian armor, with a cross across
displayed on his upper body, and a blood-red
cloak billowing out behind, held fast by two
ruby cabochons. The young and beautiful
man appears to have achieved his goal. Yet his
journey must have been difficult, given that

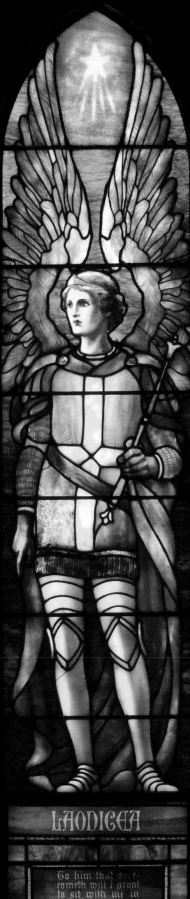

LAODICEA

To him that over-
cometh will I grant
to sit with me in
my throne. ✠ ✠
Rev. iii. 21

the epistle to Laodicea is the harshest of all the seven letters.

**GEOGRAPHICAL SETTING** The historical Laodicea was indeed a wealthy city. Founded on the site of an older town whose origins have been lost, Laodicea was built between 261 and 253 BCE by Antiochus II Theos, ruler of the Seleucid kingdom, in honor of his wife Laodice. In 133 BCE the town fell under Roman control and quickly began to benefit from its advantageous position on a major trade route, developing into a banking capital and a bustling commercial center.

So wealthy was the city that, after an earthquake in 60 CE, it was rebuilt by private donations. In particular, it was known for its manufacture of fine black wool (which stands in stark contrast to the pure white robe the Laodiceans are told in Revelation to wear). It also boasted of a famous medical college; one of the specialties of this center was an ointment for strengthening the ear canal.[1] But there was another ointment, a "Phrygian powder," that was used to cure eye disease.[2]

*Ruins of Laodicea,* 1847 by William Miller (1796–1882). Laodicea was a wealthy city, due to its position on a major trade route. It developed under Roman rule, becoming a banking and commercial capital.

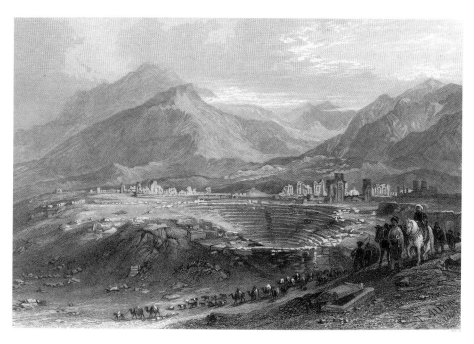

*Sheep, Rams and Goats at the Gate*, c. 1860 by Wilhelm Melchior (1817–60). Laodicea was particularly known for the production of fine black wool. This contrasts sharply with the command in Revelation for the citizens to wear pure white robes.

As with all these Rome-dominated Asian cities, Laodicea had a pagan past. Bible scholar Roland Worth mentions just a few of the many and various deities of Laodicea: Hera, Athena, Mithras, Dionysus, Helios, Apollo, and Rome itself. The most important, however, was Zeus (as Zeus Aseis and Zeus Laodicenus), who was celebrated in an annual Zeus festival.[3] In fact, one of the original names of the city was Diospolis, "City of Zeus."

The second most important deity of the city was Men Karou, a moon god of the Phrygian people, who was the city's original protector. At the time of Revelation, a market dedicated to his name operated in Laodicea. There was also a large community of Jews; both W. M. Ramsay and Colin Hemer believe that they were an important and influential part of the citizenry.[4]

*Zeus with a laurel crown*, gold stater from Lampsacus, c. 360–340 BCE, Cabinet des Médailles, Bibliothèque nationale de France, Paris. The original name of Laodicea was "Diospolis" or "City of Zeus."

All in all, then, the Laodicean Christian community had a lot of temptations: the lure of wealth, of pagan deities, and of another monotheistic religion. Undoubtedly, many of the church lapsed from their original ardor and dedication.

## BIBLICAL MEANING

The church of Laodicea is described as "lukewarm . . . neither cold nor hot"(Rev. 3:16). It will be spit out, like foul water. Despite its faults, it glories in its supposed good fortune: "I am rich, I have prospered, and I need nothing"

*Hope,* 1886 by George Frederic Watts (1817–1904), oil on canvas, Tate Britain. The church of Laodicea believes that it is wealthy, but it is lukewarm spiritually. In reality it is like a blind beggar, stumbling through spiritual twilight, and unless it changes it ways, will be spit out, like foul water.

(3:17). Yet it is really a naked, blind beggar. In order to achieve the promised throne, it must be refined by fire and trial and must have its eyes opened by a special salve—possibly a reference to the city's famous exports.

**SPIRITUAL SENSE**  For Swedenborg, the church of Laodicea represents a person who profanes religious and spiritual beliefs. In this person's outer world, when he is in society, he may say that he has faith; yet he falters when he looks into his own heart. This type of person can believe wholeheartedly at certain times and then renege when he falls prey to earthly temptations. Once he turns his back, he thinks only of his own place in the world.

The condition of being "lukewarm" renders this person in a precarious spiritual state, since he mixes good and evil and often uses what he has learned of religious truths to advance his own selfish motives. It would be better, as the letter itself says, to be simply evil or good rather than to use truths for evil purposes or commit spiritual adultery. In the afterlife, such a person lives in wild fantasies, finding neither an angelic nor a demonic community, as is explained

in chilling detail in Swedenborg's *Divine Providence* §226:

> They seem to themselves to be flying around in the air; and when they come to rest they toy with their illusions, which they see as real. Since they are no longer human, they are not referred to as "he" or "she," but as "it." In fact, when they are exposed to view in heaven's light they look like skeletons, sometimes the color of bones, sometimes fiery, and sometimes charred.

This horrific destiny is merited because the person can no longer separate the good inside him from the evil, as is meant to happen in the World of Spirits, where all people go after death. In life, according to Swedenborg, we are at times aligned with heaven and at times with hell; we veer toward good or evil according to our actions. In the World of Spirits, our true nature is exposed, and we are purged of either the good or the evil, depending on whether we choose a home in heaven or in hell. However, when a person believes fervently in truth and God's wisdom and then lapses from that belief, he mixes good and evil so thoroughly in his being that they cannot be separated in the afterlife. Such a situation cannot be tolerated: heaven cannot have anything of evil, and hell cannot have anything of good. These lonely souls must wander aimlessly, living, as it were, neither here nor there.

In Swedenborg's view, the "wealth" that the Laodicean has is neither monetary nor tangible; rather, it is a belief that this person knows the truth of his religion through his own power. In his delusion, his mind is shut to heavenly light, the only source of enlightenment and truth. This man is "wretched, pitiable, poor, blind, and naked" (Rev. 3:17), signifying that he lacks all knowledge of good and truth.

*The Light of the World,* 1851 by William Holman Hunt (1827–1910), Manchester Art Gallery. "Listen! I am standing at the door, knocking; if you hear my voice and open the door, I will come in to you and eat with you, and you with me." The door in this painting has no handle, and therefore can only be opened from the inside. Christ cannot enter until the door is opened for him.

But all is not lost. If the seeker undergoes a transformation, he can escape the fate of the skeletal wanderer in the afterlife and be assured a heavenly seat. First, he must acquire for himself "gold refined by fire," which Swedenborg defines as the good things that come from the Lord. Next, the seeker must adorn himself with white garments, signifying genuine wisdom, which will be given to him if he opens his heart and mind to God's love. Finally, he must open his eyes and keep them open; never again must he fall prey to the delusions of his own power and understanding and the misuse of divine gifts.

## SPIRITUAL MEANING OF THE DETAILS

Again, we see in Swedenborg's interpretation the combination of divine love and wisdom, the unity that comprises heaven. Tiffany's angel of Laodicea epitomizes that unity in color and symbol.

Tiffany's angel has overcome the trials. His eyes are open and clear. The armor he wears is gold, the color of celestial good, which protects him on his journey. He wears a cross on his armor, signifying his victory over temptations. The golden crown signifies that he has attained wisdom proceeding from love, while his golden scepter indicates divine truth. The rubies that clasp his cloak are especially significant. They represent the truth of celestial good; indeed, in Swedenborg's *Sacred Scripture* §42, the Word is described as a "ruby by virtue of its celestial flame." The red of his cloak and the greenish tinge of his armor represent, respectively, the good things that come from love and the flourishing of life. In effect, the Laodicean has mastered his faults while on earth, so that he can achieve a heavenly victory.

This angel carries an important message for all, as it warns people who would misuse spiritual wisdom for their own purposes. It is representative of the second commandment, where we are told not to take the Lord's name in vain, because using the name of God with bad intent also represents a mixing of good and evil. It is better to stay a materially focused human being, with no spiritual aspirations, than to be a hypocrite and spoil what is good by advancing our selfish aims or claiming that the wisdom we gain on the spiritual path comes from ourselves alone.

It is necessary to be vigilant about how we use the insights and wisdom we gain as we seek to become more spiritual beings. We must be careful to advance at a pace that we can manage, so as to hold in gratitude and as sacred the wisdom we acquire. To touch the divine and then use that for selfish purposes is a type of spiritual adultery, a misappropriation of divine gifts. This is the state of being lukewarm, and it is a very dangerous one. When one turns to divine guidance for understanding and begins to lead a life that shuns selfish goals, it is possible to be healed. Anyone who pledges to live a good life and then does so, with help and guidance from above, opens the door for the Lord to enter. ✦

*Ecclesiastical Angels,* c. 1980 by Tiffany Glass & Decorating Co., Richard H. Driehaus Gallery of Stained Glass, Chicago. Relying on human understanding only encourages selfish goals. One must turn to divine guidance in order to lead a life that shuns selfish goals, and promotes spiritual healing. Anyone who pledges to live a good life and then does so, opens the door for the Lord to enter.

PRAYER

*Lord, as I continue on this spiritual path,*
*let me be ever wary of the pitfalls*
*of using what I have learned*
*for my own purposes.*
*Help me stay loving and true*
*and always aware that the source*
*of all love and wisdom is from you.*
*Open the door when I knock,*
*when I am ready,*
*and give me the strength and clarity*
*to stay in alignment with your truth.*
*In this way, I will do your work*
*with a clear and open heart.*
*Amen.*

# Conservation of the Windows

by Arthur Femenella
*President, Femenella & Associates*

Art Nouveau is a direct descendant of the Arts and Crafts movement, and both had a profound influence on the decorative arts in the United States. One of the leaders of the Art Nouveau movement, Louis Comfort Tiffany, fabricated the angel windows depicting the seven churches of the book of Revelation that were originally housed at the Church of New Jerusalem in Cincinnati, Ohio.

Louis Comfort Tiffany 1871.

Tiffany thrived through a unique combination of social connections, powerful marketing, and a fresh creative approach to decorative arts and interior design. In the words of Neil Harris, noted Tiffany essayist, "Before 1879, Tiffany had done no interior designs at all. Within three years he was taking orders from the White House."[1] Ten years later, at the Columbian exposition in 1893, over one million people would visit his Byzantine chapel and sing his praises. Fueled by post-Civil War wealth and the religious enthusiasm of the 1890s, churches, public buildings, and great private mansions were sprouting up across the landscape. The owners of these buildings clamored for the rich decoration offered by Tiffany's firm. The Church of the New Jerusalem in Cincinnati was indicative of the best buildings and the richest decorations of this gilded age. Tiffany

himself must have considered them representative pieces, because these angel windows are listed in a catalog of the studio's creations titled "Examples of Our Work," published circa 1912 or 1913.

The windows are examples of the best the Tiffany Studios had to offer. The visual impact of the windows is created through a rich and varied palette of opalescent, drapery, flashed, and antique glass.

*Opalescent glass* is a generalized term for clear and semi-opaque pressed, cloudy, or marbled glass that is sometimes accented with subtle coloring, combining to form a milky opalescence in the glass. While René Lalique's art may be recognized by some as the pinnacle of opalescent glassmaking, John La Farge and Louis Comfort Tiffany were driven by their desire to create beautiful visual scenes in glass without painting by experimenting with opalescent effects. Opalescent glass was first developed and patented by La Farge in 1879, but it was Tiffany who created the masterworks in glass for which he is still so well known today. Opalescent glass can be manipulated while hot to form, for example, the exquisite drapery of the angels' gowns or the electric ripples of the angels' wings. It is formed into the exquisite pressed and hand-faceted glass jewels and slabs that highlight the windows, such as the stone in the Pergamos window or the crown in Thyatira.

The textures and colors in the stone held by the angel of Pergamos (top) and the crown on the angel of Thyatira (bottom) were created with opalescent glass.

*Drapery glass* was invented by Tiffany Studios specifically to produce the effect of flowing fabric in stained glass. In this technique, a partially molten sheet of glass is rolled by hand with an instrument resembling a rolling pin. The glass may be folded over or pulled with tongs while being rolled to increase the desired rippled effect.

*Antique glass* is more accurately described as mouth-blown glass or cylinder glass. To start, a large blob of molten glass is held on the end of a long, hollow metal tube or blowpipe. The glassworker then blows air into the blob to form a small bubble. The glass is repeatedly reheated and more air blown in until the bubble extends two or more feet long. The ends of the bubble are cut off, forming a cylinder. The cylinder is then slit along its length and opened in the oven to form a sheet. A variation on this technique is *flashed glass.* The artist starts with a layer of mouth-blown glass with a light tint of color. As the final sheet is formed, a thin layer of glass in an intense, contrasting color—the "flash"—is fused onto the lighter glass. The intense flash layer can be partially removed through abrasion or acid etching to reveal the tint below, producing amazing artistic effects.

René Lalique

Flashed glass is employed to great effect in the windows featured in this book. For example, the vibrant wings of the angels were created using tightly rippled opalescent glass backed by large sheets of soft, acid-etched red flashing on clear glass. This produces the gradual fading of the red highlights on the wings. A similar device is used for the chain mail of Laodicea's arm, except that the flashed glass is hard etched rather than acid etched. The names of the angels are also hard etched onto flashed glass in negative: the surrounding color has been removed to leave the names in color.

*Plating* is used to great advantage within the windows. Plating is a device wherein layers of glass are mechanically layered together—sometimes multiple layers in a high-heart lead came (a lead channel that holds the glass together at the edges) or individual layers secured in copper foil or lead and soldered together. Plating has

Hard etching was used to produce the look of chain mail for the angel of Laodicea.

John La Farge, 1902

its origins in windows much more ancient than these angels, but it was developed and exploited by the opalescent masters, beginning with La Farge and Tiffany.

There are four layers of plating in these windows. The glass of the windows is held in a combination lead came and copper foil matrix. Many of the organic lines are executed in copper foil. The use of copper foil in stained glass windows was patented by Sanford Bray of Boston in 1886. Two years later, Tiffany bought Bray's company. The first foil window by Tiffany was the *Four Seasons* window in 1900.[2] In the copper foil process, the copper serves as a substrate for the solder to adhere to. In and of itself, the copper lends very little strength to the structure of the window. By manipulating the line of the applied copper foil, one can control the ultimate shape of the solder bead. In this way, the early opalescent artists created very organic lines. Tiffany often juxtaposed the organic line against the more architectural line of lead cames, as he has done in the angel windows. The interior surfaces of the lead cames have been floated (tinned) with solder. This was a common practice for the Tiffany Studios. I believe it was done for primarily aesthetic purposes, resulting in continuous flowing lines throughout the design. This matrix is further supported by round saddle bars that are set into the wood sash and connected to the matrix with copper tie wires.

Tiffany created flesh tones with various types of paint, seen here in the angel of Smyrna.

The faces and flesh of the angels are painted in these windows with vitreous trace, matte, and enamel paints. There is limited use of silver stain. The paint is made of ground glass, metallic oxide coloring agents, and a flux to lower the melting temperature. It is applied to the interior surface of the glass via one or more media, such as gum Arabic and water, oil, alcohol, and so

Example of the typical dirt accretion between plates.

on. After drying and manipulation of the paint with stiff brushes and/or wood picks, the glass is fired in a kiln at between 1050 F and 1250 F. It is fired until, depending on the chemical nature of the particular paint, it vitrifies and becomes one with the glass substrate. In many instances, paint is applied to multiple layers of glass, as was done in the heads of the angels.

When they were brought to our company for restoration, the windows evinced a typical level of deterioration for their age. Extensive accretions of dirt and dried-out putty had collected between the plates and on the surfaces of the all of the glass, including the interior plates. There was deflection in many of the panels, meaning that the lead matrices had deteriorated from wear. This was most evident in the ventilator panels, due to the added forces generated by opening and closing them. Some of the lead cames that were supporting the back plates were fatigued and corroded and needed replacement. There were cracked pieces of glass throughout the windows.

The Swedenborgian Church at Temenos did not have a building suitable for the installation of the Tiffany windows. The church's plan for the windows was to develop a traveling exhibition so that the beauty of the windows could be shared with all. This exhibition

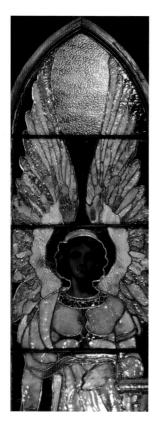

Window with reflected light.

concept directed our conservation effort to be resolved as follows:

- All procedures should be as non-invasive as possible and completely reversible
- We would conserve as much original material as possible
- Due to the close proximity at which the windows would be viewed, the conserved condition of the windows would be as close as possible to their original condition

To satisfy these project goals, we decided to conserve the windows without removing them from their original wooden sash. This meant we could save the original tie wires and saddle bars and preserve the original patina of the lead came/copper foil matrix on the viewing side of the glass. The windows were delivered to The Art of Glass, Inc. in Media, Pennsylvania. I worked closely with Kathy Jordan, the owner of the studio, and her craft personnel on the conservation project. Kathy and I had worked on a number of Tiffany projects together in the past and I was confident working with her and her team on the angel windows.

The windows were fully documented with photography in transmitted and reflected light, and rubbings of the panels were made on archival quality rag vellum. Notations were added to the rubbings to indicate existing damage such as broken glass, deflection, paint deterioration, and previous repairs. The location of plating was also noted. This was a bit challenging with the windows still in the sash, but it can be accomplished. We set the windows onto easels lying over on the jamb of the sash but kept the window in a vertical plane. This allowed us to begin the cleaning process and learn more about any possible damage to the

internal plates. We made plywood supports covered with soft foam to support the glass and moved the panels to the workbench. The plates were removed from the back of the window without applying any pressure to the front glass. All of the layers of plating were removed down to the base or front layer of glass. For the most part, the front layer was left in the leads.

There was an exception to this process. One of the heads had to be removed so we could glue a white opal back plate. Due to the way this head and its back plates were copper foiled into the matrix, it was safer to access this plate from the front of the window for gluing. Removal of the plates is facilitated by making little handles of tape that are attached to the pieces of glass. As the leads are gently pressed back, the piece can be gently jiggled with the tape and lifted from the matrix. We did not cut away any existing leads that were not fatigued or corroded to the point that they could not be saved. A key to saving the existing lead is to treat it gently. It's a bit like getting the shy girl at the prom to dance: be gentle but persistent.

As the glass plates are removed, the accretion of dirt is cleaned from the interstitial spaces. It is amazing how much dirt can collect there. We use gentle methods such as soft bristle brushes and a low-power vacuum to remove loose dirt and putty, and Orvus— a non-ionic surfactant—for the dirt that is adhered to the glass. The plates are stored on working rubbings until they are ready for crack repair or the rebuilding of the panel. The faces and painted surfaces are cleaned with naphtha, a petroleum-based solvent, on cotton swabs. The area to be cleaned is illuminated from behind, and the cleaning motion follows the paint lines of the piece. One must constantly

Cleaning one of the angel faces.

monitor the progress to ensure that no paint is being removed.

The ventilator panels are the only panels that were completely dismantled due to their advanced state of deterioration and their method of construction; the glass was double and triple plated within high-heart leads. The panels were carefully taken apart and the original leads were reused when the ventilator panels were put back together. Although Tiffany's "Partial List of Windows"[3] and church archives had previously confirmed the attribution of the windows to Tiffany, cleaning of the last ventilator window in the series revealed the signature of the Tiffany Studios.

All of the broken glass was indicated on the rubbings and then edge-glued. For most of this work, a room temperature vulcanization (RTV) silicone product is used. It is best to use an acid-cure product because the adhesion is a bit better than neutral-cure products. It is important to let the silicone fully vulcanize before rebuilding so the outgassing of acetic acid as the silicone cures does not adversely affect the lead cames. We used Hxtal NYL-1 conservation epoxy to glue some of the pieces. Hxtal was used on the back plate of the face that was removed and for the large, etched plates from the back of the window. The relative strength and

clarity required for the joint dictated whether we used the silicone or the Hxtal. For most of the opalescent and drapery glass, the surface area at the break and the size of piece allowed us to use the silicone, a more conservative product. Pieces that were large in size (thereby exerting more force at the crack) or that had thin, etched plates required the use of Hxtal. For some of the cracks in the front layer of glass, we are able to glue them in situ. We liberally flushed the crack with isopropyl alcohol and allowed the crack to dry. After taping the piece to limit the migration of the adhesive and to hold the piece together, we infused the crack with Hxtal. Using an incandescent light bulb to gently heat the backside of the piece aids the capillary action and draws the epoxy into the crack.

The panels were now ready for rebuilding. Wherever two plates were of the same exact shape, we attached them together with a skim coat of silicone on the common edges. This makes the panels stronger by acting as a splint for any broken pieces, and it keeps dirt from migrating between the pieces of glass. Some advocate the use of copper foil for this purpose, but I do not think it is as effective as silicone. After the pieces were reinserted into the panel, the leads were encouraged back into position. Where necessary, new leads were added. When applying layers of lead for plating, we pre-tinned the solder joints and cleaned away the flux. The joints were then soldered without flux. This helps to keep the flux from working its way down into the panel. Because these are exhibition panels, they were not waterproofed in their entirety. Putty was used for light leaks and to quiet rattles. The windows were in their original sash, but the sashes were fragile. We made frames from steel with a Z-shaped angle for each

panel, and attached the frame to the side of the sash jamb. This gave a great deal of rigidity to the windows and allowed them to be easily installed into light boxes for display.

The windows were ready for exhibition. Custom travel boxes were built employing the concept of a box within a box. The windows were fitted into stout boxes with foam custom-cut to support the stained glass firmly, but softly. Each one of these boxes was then installed into a larger box floating on a layer of more rigid foam. A video of the packing and unpacking process was made to accompany the windows as they traveled to assist museum personnel with installations. Light boxes were also fabricated to accompany the windows as they traveled. The steel sub-frames that were added to the Tiffany sash easily attach within the light boxes, or they can allow for the widows to be set into a false wall at a museum if natural light is available.

It was a great pleasure and honor to work on these magnificent windows. It is our fervent hope that they will endure for centuries and continue to touch the hearts and souls of all those that view them. ✤

Angel Laodicea partially dismantled.

# Notes

## INTRODUCTION

1. This story is told in more detail in *In Company with Angels: Seven Rediscovered Tiffany Windows,* an exhibition catalog from the Newcomb Art Gallery, Tulane University (exhibition March 4–June 28, 2009), 9. More information on the exhibit is available at the website www.incompany withangels.org.

2. Femenella & Associates, Inc., have participated in many Tiffany restoration projects, including the Belasco Theatre, New York; St. Paul's Church, Nantucket, Massachusetts; the United States Naval Academy Chapel, Annapolis, Maryland; Grace-St. Luke's Church, Memphis, Tennessee; the First Presbyterian Church, Germantown, Philadelphia; and the Second Presbyterian Church, Chicago. See www.femenellaassociates.com.

3. Blake, although he was to repudiate Swedenborg's influence later in his life, participated in meetings of the General Conference, the first Swedenborgian denomination, in Eastcheap, London, and maintained close relations with Swedenborgians such as the sculptor John Flaxman (see Harvey F. Bellin, "'Opposition is True Friendship': Swedenborg's Influence on William Blake," in *Emanuel Swedenborg: A Continuing Vision,* ed. Robin Larsen et al. [New York: Swedenborg Foundation, 1988], 92, 93). Emerson made Swedenborg one of his *Representative Men* (1850), along with Plato, Montaigne,

and Shakespeare. In a letter to her sister dated December 1856, Elizabeth Barrett Browning acknowledged Swedenborg's influence on her epic poem *Aurora Leigh* (1857). Helen Keller declared herself a Swedenborgian in her "spiritual autobiography" *My Religion* (1927). Henry James Sr. believed he had undergone a spiritual regeneration, which he described, following Swedenborg's terminology, as a "vastation," and wrote about it in *The Secret of Swedenborg* (1869).

4. Anita S. Dole, *Bible Study Notes,* ed. William R. Woofenden, vol. 6, *John–Revelation* (West Chester, PA: Swedenborg Foundation, 2001), 179.

5. *Emanuel Swedenborg, Apocalypsis Explicata . . .,* 4 vols. (London, 1785–89); published more recently in English as *Apocalypse Explained,* trans. John C. Ager and Rev. John Whitehead, 6 vols. (West Chester, PA: Swedenborg Foundation, 1994–1997). The Whitehead revised translation dates from 1911, with some minor revisions by editor William Ross Woofenden in the edition published in the 1990s.

6. Emanuel Swedenborg, *Apocalypsis Revelata . . .* (Amsterdam, 1766); published more recently in English as *Apocalypse Revealed,* trans. John Whitehead, 2 vols. (West Chester, PA: Swedenborg Foundation, 1997). The Whitehead translation dates from 1928; currently, the Swedenborg Foundation is preparing a new translation of this work in two volumes, to be titled

*Revelation Unveiled.* According to William Ross Woofenden, who edited the edition printed in 1997, "there is some difference of opinion as to whether this is, as [one of its translators] F. Coulson, says, 'a condensed and modified version' of the earlier incomplete work, *Apocalypse Explained,* or a completely new and independent explication of the last book of the Bible. The weight of evidence seems to be with the latter view. Unlike the earlier work, this one is openly addressed to the Christian world, and thus marks an apparently new attitude on the part of the author as to where the New Church proclaimed in writings was to have its origin." Quote taken from "Bibliography of Swedenborg's Works," compiled and annotated by William Ross Woofenden, PhD, in *Emanuel Swedenborg: A Continuing Vision* (New York: Swedenborg Foundation, 1988), 520.

7.   Emanuel Swedenborg, *The Last Judgment in Retrospect,* ed. and trans. George F. Dole (West Chester, PA: Swedenborg Foundation, 1996). In brief: "With the Last Judgment in 1757, as [Swedenborg] sees it, the era symbolized by the 'old' Christian Church came to an end. The Second Coming—the return of the Lord after his resurrection and glorification described in the Gospels—ushers in a new Christianity and the establishment in 1770 of a new church in the spiritual world. He stated at one point that the church in the outward world would go on much as before, at least for a while. . . . He expected . . . that a new freedom of thought in spiritual matters would counter the dogmatism of traditional Christianity." Quote taken from George F. Dole and Robert H. Kirven, *A Scientist Explores Spirit* (West Chester, PA: Swedenborg Foundation, 1997), 74.

8.   While *Apocalypse Explained* and *Revelation Unveiled* provide this exegesis, a reader can also go to *A Dictionary of Correspondences* (originally published in 1800 and revised in 1847) for a remarkable compilation of the internal meanings of words, objects, people, and incidents in the Bible. George Nicholson, *Dictionary of Correspondences: A Key to Biblical Interpretation,* 15th ed. (West Chester, PA: Swedenborg Foundation, 2010).

9.   According to Hugh F. McKean, however, Inness wasn't much of a teacher: "Apparently, all Tiffany did was sit in a corner and watch Inness paint" (*The "Lost" Treasures of Louis Comfort Tiffany* [Garden City, NY: Doubleday & Company, 1980], 2). For information on Inness and the profound influence of Swedenborg on his life and art, see Adrienne Baxter Bell, *George Inness and the Visionary Landscape* (New York: George Braziller, 2007). Tiffany began as a painter, but as his glass business grew to become one of the most famous and successful in the world, he himself designed only the most prestigious works, although he gave his personal approval to all projects. The design department, headed by Tiffany's hand-picked men— and a few women, who were paid less than their male counterparts—designed all but the most prominent window commissions. Alastair Duncan, *Tiffany Windows* (New York: Simon & Schuster, 1980), chap. 3.

10.   Quoted in McKean, *The "Lost" Treasures of Louis Comfort Tiffany,* 47.

11.   According to Alastair Duncan, "The decision to manufacture lamps was a commercial one: to utilize the offcuts of glass which had been too small to incorporate into windows" (*Tiffany Windows,* 15).

12.   Ibid., 15–16. Duncan's book lists in an appendix "A Partial List of Tiffany Windows," which comprises twenty-five pages, set in minuscule type, over three columns per page. The windows that concern the present book are listed on page 218, third column: "Church of the New Jerusalem (Church demolished; windows removed)[:] *Lawson Memorial Window, "Christ on Road to Emmaus." Memorial Window, "Angels Representing Seven Churches."* Unfortunately, many of Tiffany's windows were not removed when their churches were demolished but were destroyed by bulldozers and

sledgehammers. Fire was another destroyer of Tiffany's glass, as many churches (and private residences that also had his windows) burned to the ground. See also Duncan, *Tiffany Windows,* 97.

13. William Bruce, *Commentary on the Revelation of St. John* (London: James Speirs, 1877).

## THE ANGEL OF EPHESUS

1. Duncan, *Tiffany Windows,* 97.

2. W. M. Ramsay, *The Letters to the Seven Churches,* ed. Mark W. Wilson (Peabody, MA: Hendrickson Publishers, 1994), 134–137.

3. Ibid. Ramsay, an archeologist and biblical scholar, connects the messages of the letters to the history, natural environment, and commercial and social conditions of each of the cities at the time of Revelation. The scholarly approach followed in this book is based on Ramsay and on Colin J. Hemer's *The Letters to the Seven Churches of Asia in Their Local Setting,* Biblical Resource Series (Grand Rapids, MI: William B. Eerdmans Publishing Company; and Livonia, MI: Dove Booksellers, 2001).

4. Ramsay, *The Letters to the Seven Churches,* 145. Ramsay believes that the Nicolaitans represented a "danger within"; they "emphasized close relations with the best customs of ordinary society." E. M. Blaiklock, however, sees the Nicolaitans differently: "It is fair to assume that they were Greeks who saw in their own cults a measure of true revelation, a position that might have arguments to commend it, but who carried this belief to the point of advocating unwise compromise with the debased forms of those cults in such prominence around them." ("Ephesus," in *The Zondervan Pictorial Encyclopedia of the Bible,* gen. ed. Merril C. Tenney [Grand Rapids, MI: Zondervan, 1975], 2:330).

5. Nicholson, *Dictionary of Correspondences,* 9, 369.

6. Ramsay asserts that the Ephesians, who were mostly pagans who converted to Christianity, would also associate the Tree of Life with the sacred tree of pagan religion and folklore (*The Letters to the Seven Churches,* 180), such as the golden bough that gained Aeneas access to the underworld.

## THE ANGEL OF SMYRNA

1. Susannah Currie, Arthur J. Femenella, and Sally A. Main, *In Company with Angels: Seven Rediscovered Tiffany Windows,* ed. Teresa Parker Farris (New Orleans: Tulane University, 2009), 21. Published in conjunction with the exhibition of the same name in the Newcomb Art Gallery. See also Duncan, *Tiffany Windows,* 97–102.

2. Ramsay, *The Letters to the Seven Churches,* 183; "Smyrna," in *The Zondervan Pictorial Encyclopedia of the Bible,* 5:462.

3. "Smyrna," in *The Zondervan Pictorial Encyclopedia of the Bible,* 464.

4. Ramsay, *The Letters to the Seven Churches,* 184–86.

5. Ibid., 202.

6. Bruce, *Commentary on the Revelation of St. John,* 55.

7. Further, in *Revelation Unveiled* §913, Swedenborg elaborates on the meaning of other metals: "Gold answers to the good that love does, silver to the truths that wisdom provides, copper or bronze to the good that caring does, and iron to the truths that faith discloses. That is why these metals are found in the spiritual world as well—because everything we find there reflects something deeper."

## THE ANGEL OF PERGAMOS

1. Hemer, *The Letters to the Seven Churches of Asia in Their Local Setting,* 82–84.

2. Ramsay, *The Letters to the Seven Churches,* 207.

3. Hemer also suggests that the Nicolaitans were somehow connected with Gnostic teachings (88).

4. Ibid.

5. Ibid., 96. Hemer does not decisively choose one of these suggestions as the best; see the discussion on pages 96–102.

6. Bruce, *Commentary on the Revelation of St. John,* 56.

## THE ANGEL OF THYATIRA

1. E. M. Blaiklock, "Thyatira," *The Zondervan Pictorial Encyclopedia of the Bible* (Grand Rapids, MI: Zondervan, 1975), 744; Ramsay, *The Letters to the Seven Churches*, 238; Hemer, *The Letters to the Seven Churches of Asia in Their Local Setting*, 111–17.

2. Ramsay, *The Letters to the Seven Churches*, 238.

3. Hemer, *The Letters to the Seven Churches of Asia in Their Local Setting*, 109, 110–11.

4. Bruce, *Commentary on the Revelation of St. John*, 67.

5. Hemer summarizes scholars' interpretations: "[The bed] has been variously explained as a bed of pain or a funeral bier, or ironically of a dining-couch, with the implication that this was the emblem of her sin. . . . [T]he primary meaning is probably 'sick bed'" (121).

## THE ANGEL OF SARDIS

1. Hemer, *The Letters to the Seven Churches of Asia in Their Local Setting*, 148–49.

2. Ramsay, *The Letters to the Seven Churches*, 280.

3. Ibid., 276.

4. Bruce, *Commentary on the Revelation of St. John*, 75.

5. This system is explained in Swedenborg's *Heaven and Hell* §§20–40.

6. Bruce, *Commentary on the Revelation of St. John*, 81.

## THE ANGEL OF PHILADELPHIA

1. Ramsay, *The Letters to the Seven Churches*, 286–87.

2. The earthquake of 17 CE and its effect on Philadelphia is discussed at length in Ramsay, 290–91, and Hemer, *The Letters to the Seven Churches of Asia in Their Local Setting*, 156–60.

3. Hemer, *The Letters to the Seven Churches of Asia in Their Local Setting*, 157. Hemer also reports that, under Vespasian (69–79 CE), "the city took the imperial epithet 'Flavia' . . . . It was a great honour for a city to be permitted to assume such titles, and they bound it closely to the imperial service. . . ." (157–58). "Flavia" referred to the Flavian dynasty, established by Vespasian; it ended with Domitian in 96 CE.

4. Ibid., 155–56, 158–59.

5. Ibid., 160.

6. Ibid., 8.

7. George H. Allen, "Rome," in *International Standard Bible Encyclopaedia*, ed. James Orr (Chicago: The Howard-Serverance Company, 1915), 4:2623.

## THE ANGEL OF LAODICEA

1. Ramsay, *The Letters to the Seven Cities*, 306.

2. Roland H. Worth Jr., *The Seven Cities of the Apocalypse and Greco-Asian Culture* (New York/Mahwah, NJ: Paulist Press, 1999), 216.

3. Ibid., 211.

4. Ramsay, 309–311; Hemer, *The Letters to the Seven Churches of Asia in Their Local Setting*, 182–86.

## CONSERVATION OF THE WINDOWS

1. Neil Harris, "Louis Comfort Tiffany: The Search for Influence," in *Masterworks of Louis Comfort Tiffany*, Alistair Duncan, Martin P. Eidelberg, and Neil Harris (New York: Harry N. Abrams, 1989).

2. McKean, *The "Lost" Treasures of Louis Comfort Tiffany*, 63.

3. *A Partial List of Tiffany Windows* (Tiffany Studios, 1973). See also Duncan, *Tiffany Windows*, 218.

# Bibliography

## By or about Emanuel Swedenborg

### *Primary*

Swedenborg, Emanuel. *Apocalypse Explained.* Translated by John C. Ager. Revised by John Whitehead. 6 vols. West Chester, PA: Swedenborg Foundation, 1994–1997.

———. *Apocalypse Revealed.* Translated by John Whitehead. 2 vols. West Chester, PA: Swedenborg Foundation, 1997. A new translation of this work, titled *Revelation Unveiled,* is forthcoming from the Swedenborg Foundation.

———. *Divine Providence.* Translated by George F. Dole. West Chester, PA: Swedenborg Foundation, 2003.

———. *Heaven and Hell.* Translated by George F. Dole. West Chester, PA: Swedenborg Foundation, 2000.

———. *Secrets of Heaven.* Translated by Lisa Hyatt Cooper. vol. 1. West Chester, PA: Swedenborg Foundation, 2008.

### *Secondary*

Bruce, William. *Commentary on the Revelation of St. John.* London: James Speirs, 1877.

Dole, Anita S. *Bible Study Notes.* Edited by William R. Woofenden. 6 vols. West Chester, PA: Swedenborg Foundation, 2001.

Dole, George F., and Robert H. Kirven. *A Scientist Explores Spirit: A Biography of Emanuel Swedenborg, with Key Concepts of His Theology.* West Chester, PA: Chrysalis Books, 1997.

Larsen, Robin, Stephen Larsen, James F. Lawrence, and William Ross Woofenden, eds. *Emanuel Swedenborg: A Continuing Vision.* New York: Swedenborg Foundation, Inc., 1988.

Nicholson, George. *Dictionary of Correspondences: The Key to Biblical Interpretation.* 15th ed. West Chester, PA: Swedenborg Foundation, 2010.

Taylor, Douglas. *Landmarks in Regeneration.* Bryn Athyn, PA: General Church of the New Jerusalem, 2005.

*The Sower: Helps to the Study of the Bible in Home and Sunday School.* Memorial Edition. Vol. 6 Boston: Massachusetts New-Church Union, n.d.

Warren, Samuel M. *A Compendium of the Theological Writings of Emanuel Swedenborg.* West Chester, PA: Swedenborg Foundation, 2009.

Worcester, John. *Correspondences of the Bible: The Animals.* West Chester, PA: Swedenborg Foundation, 2009.

———. *Correspondences of the Bible: The Human Body.* West Chester, PA: Swedenborg Foundation, 2009.

———. *Correspondences of the Bible: The Plants.* West Chester, PA: Swedenborg Foundation, 2009.

## About Biblical Scholarship

Carrington, Phillip. *The Early Christian Church.* Vol. 1, *The First Century.*

Cambridge: Cambridge University Press, 1957.

Hemer, Colin J. *The Letters to the Seven Churches of Asia in Their Local Setting.* The Biblical Resources Series. Grand Rapids, MI: Wm. B. Eerdmans Publishing Company, 2001.

Ramsay, W. M. *The Letters to the Seven Churches.* Edited by Mark W. Wilson. Updated ed. Peabody, MA: Hendrickson Publishers, Inc., 1994.

Worth, Roland H., Jr. *The Seven Cities of the Apocalypse and Greco-Asian Culture.* New York/Mahwah, NJ: Paulist Press, 1999.

*The Zondervan Pictorial Encyclopedia of the Bible.* General Editor Merrill C. Tenney. 5 vols. Grand Rapids, MI: Zondervan, 1975.

## ABOUT LEWIS COMFORT TIFFANY AND ANGEL WINDOWS

Amayo, Mario. *Tiffany Glass.* New York: Walker, 1967.

Currie, Susannah, Arthur J. Femenella, and Sally A. Main. *In Company with Angels: Seven Rediscovered Tiffany Windows.* New Orleans: Tulane University, 2009. Published in conjunction with an exhibition of the same name at Newcomb Art Gallery, Tulane University.

Duncan, Alistair. *Tiffany Windows.* London: Thames and Hudson, 1980.

Harris, Neil. "Louis Comfort Tiffany: The Search for Influence." In *Masterworks of Louis Comfort Tiffany,* Alistair Duncan, Martin P. Eidelberg, and Neil Harris. New York: Harry N. Abrams, 1989.

Koch, Robert. *Louis Comfort Tiffany: A Rebel in Glass.* Updated 3rd ed. New York: Crown, 1982.

McKean, Hugh F. *The "Lost" Treasures of Louis Comfort Tiffany.* Garden City, NY: Doubleday & Company, 1980.